For Kevin,
dear friend now these thirty years —
esto perpetua

Jim
January 2010

A Monument More Durable Than Brass

A Monument More Durable Than Brass:

The Donald & Mary Hyde Collection
of Dr. Samuel Johnson

An Exhibition

EXHIBITION CURATOR
John Overholt

EDITOR
Thomas A. Horrocks

HOUGHTON LIBRARY
HARVARD UNIVERSITY

2009

Distributed by Harvard University Press

This catalogue accompanies an exhibition
at Houghton Library, 26 August–14 November 2009 and
at the Grolier Club, 9 December 2009–6 February 2010.

*This volume has been published with support of the Endowment Fund for
the Donald & Mary Hyde Collection of Dr. Samuel Johnson.*

JACKET ILLUSTRATIONS:
Gilbert Stuart. *Samuel Johnson*. [1783?]. Oil on canvas. *2003JM-15 (item 72.)
Sir Joshua Reynolds. *The Infant Johnson*. [ca. 1780]. Oil on canvas. *2003JM-4 (item 5.)

ISBN-13: 978-0-9818858-2-7
ISBN-10: 0-9818858-2-9

"GENEROUS: noble of mind; open of heart; liberal; munificent; vigorous . . ."
Samuel Johnson's *Dictionary* definition might have been written to describe

MARY, VISCOUNTESS ECCLES
(1912-2003)

Her bequest of the Donald & Mary Hyde Collection of Dr. Samuel Johnson
to Harvard University's Houghton Library is a defining act of generosity
not only to Harvard, but also to the world of scholarship in which she was
both a participant and patron.

We acknowledge her philanthropy with gratitude and celebrate her
achievements with pride.

WILLIAM P. STONEMAN
*Florence Fearrington Librarian
of Houghton Library of the
Harvard College Library*

NANCY M. CLINE
*Roy E. Larsen Librarian
of Harvard College*

ROBERT DARNTON
*Carl H. Pforzheimer
University Professor and
Director of the Harvard
University Library*

Contents

Introduction

Thomas A. Horrocks

Houghton Library celebrates the tercentenary of the birth of Samuel Johnson with *A Monument More Durable Than Brass*, an exhibition that highlights selections from its world-renowned collection of Johnson and his circle, bequeathed to the library in 2004 by Mary Hyde Eccles. This magnificent bequest, an enormous addition to Houghton's extensive holdings of eighteenth-century English literature, included endowment funds for acquisitions and the hiring of personnel. Thanks to Mary Hyde Eccles' generosity, Houghton Library continues to augment its printed and manuscript material relating to Johnson and his circle. Several of these recent acquisitions are included in the exhibition and catalogue.

In 1966, Houghton Library mounted an exhibition of books and manuscripts from Donald and Mary Hyde's Johnson collection. In his introduction to the published catalogue, Houghton Librarian William H. Bond thanked the Hydes for allowing the library to borrow "lavishly" from their collections at Four Oaks Farm. "With such riches to choose from," Bond remarked, "the choice has been difficult." Bond acknowledged the "severe test" that collectors undergo when permitting a treasured book or manuscript to leave their hands for exhibition purposes. He noted that the Hydes agreed not only to part temporarily with several treasures, but generously "sent us a roomful."[1] More than forty years later, Houghton Library again proudly displays a roomful of treasures from the Hyde Collection. And it is fitting that the Grolier Club serves as a second venue for this exhibition. The Hydes were devoted to this venerable institution, both as active members (Mary was among the first women elected to membership and Donald served as president from 1961 to 1965) and Mary as a generous benefactor. In 2002, in commemoration of her ninetieth birthday, the club published a volume of Mary's essays and addresses.[2]

This exhibition is a tribute to the assiduous and shrewd collecting of the Hydes and to the benevolence of Lady Eccles. It is also a celebration of a man whose influence on the age in which he lived was as monumental as his legacy is enduring. Samuel Johnson at 300

1 *An Exhibit of Books and Manuscripts from the Johnsonian Collection formed by Mr. and Mrs. Donald F. Hyde at Four Oaks Farm* (Cambridge, Mass.: Houghton Library, 1966), v-vi.

2 *Mary Hyde Eccles: A Miscellany of Her Essays and Addresses*, edited by William Zachs (New York: Grolier Club, 2002).

continues to be relevant in an age that is centuries removed from his own. As James Engell asserts in the first of the two essays that follow, Johnson's "radical power continues to surprise. Of all authors in English not regarded chiefly as poets and novelists, Johnson remains the most popular and most profound. And no other writer's life, in so far as it is known by fact and not fueled by speculation, has fascinated readers more." In his contribution to this catalogue, Engell offers a persuasive explanation of Johnson's continuing durability as he enters his fourth century.

Johnson outlived his own century due to his colossal achievements as a biographer, editor, essayist, literary critic, lexicographer, and poet (not to mention an imposing personality that, thanks in part to James Boswell, dominates our time as it did his own). Of course, Johnson's reputation has been fortified by generations of scholars and scholar-collectors. Among the latter group, Donald and Mary Hyde were preeminent. How they (and Mary for thirty-five years after Donald's death) assembled such an extraordinary collection is the subject of William Zachs' contribution to this volume. Zachs' essay, based on research in the extensive collection of Mary Hyde Eccles' papers at Houghton Library, portrays the Hydes as astute and focused collectors who built their library with acumen, dedication, and persistence. Four Oaks Farm, their Somerville, New Jersey, residence, became not only a stop for serious book collectors of the period, but a home away from home to scholars requiring access to the Hydes' collection for their research, including Harvard professor Walter Jackson Bate, whose 1977 biography of Johnson received the Pulitzer Prize.[3] According to Zachs, "the Hydes believed that their unique collection of research materials created an obligation to scholars. Their response was to make the Four Oaks Library a center for Johnsonian studies and a model for good practice at a private research library. . . . Almost every scholar who worked on Johnson, Boswell, and Mrs. Thrale either corresponded with them or came to Four Oaks Library (some virtually moving in)."

As it was at Four Oaks Farm, so it is at Houghton Library. Almost immediately after the Hyde Collection arrived at Houghton in 2004, the library hired three cataloguers to make this exceptional resource accessible to students, faculty, and scholars in general. (The library has recently digitized its collection of Johnson letters, comprising more than half that are known to exist.) One of these cataloguers, John Overholt, subsequently appointed Assistant Curator of the Donald & Mary Hyde Collection of Dr. Samuel Johnson and Early Modern Books and Manuscripts, served as curator of *A Monument More Durable Than Brass*. The treasures on view in this exhibition comprise a mere fraction of the magnificent Hyde Collection. And what an impressive fraction it is. Overholt presents an astonishing array of books, manuscripts, prints, ephemera, and art that, with the exception of several items acquired since 2004, represents sixty years of painstaking effort on the part of Mary Hyde

3 Walter Jackson Bate, *Samuel Johnson* (New York: Harcourt Brace Jovanovich, 1977).

Eccles, initially in collaboration with her first husband, Donald Hyde, and later with the encouragement and support of her second husband, David, Viscount Eccles, to assemble one of the world's finest collections of eighteenth-century English literature.

When Mary Hyde Eccles died on 26 August 2003, Houghton Library lost not only a generous benefactor but a devoted friend of long-standing. Mary and Donald Hyde's relationship with the library began with Arthur A. Houghton, Jr., a prominent collector in his own right, who, according to Zachs, "ushered them into the social world of book collecting." It was Mr. Houghton who introduced the Hydes to William A. Jackson, Houghton Library's first director. When Donald Hyde died in 1966, Mary worked closely with Arthur Houghton and William Bond, Jackson's successor, to create a suite of rooms in the library as a tribute to her late husband. The Donald Hyde Rooms opened in 1977 and today house the Hyde Collection. The rooms serve as a constant reminder of Mary Hyde Eccles' special attachment to Houghton Library and of her warm friendship with several of the library's directors, including Jackson, Bond, Richard Wendorf, and William Stoneman.

The editor wishes to acknowledge those individuals who in various ways made the exhibition and this catalogue possible: Simon Eccles for his stewardship of Mary's bequest to Houghton Library and numerous other institutions; Harvard colleagues Nancy Cline, William Stoneman, Carie McGinnis, Mary Oey, Susi Barbarossa, and Sage Rogers; Eric Holzenberg and Megan Smith of the Grolier Club; James Caudle, secretary of the Johnsonians; and Duncan Todd for designing and producing this catalogue. The editor thanks James Engell and William Zachs for contributing essays to this volume. John Overholt deserves special thanks for conceiving and curating this exhibition. Finally, the editor acknowledges the enduring vision and the generosity of Mary Hyde Eccles. It is to her memory that *A Monument More Durable Than Brass* is dedicated.

Perdurable Johnson

James Engell

Shakespeare, Johnson remarks, "long outlived his century," the rough proof of a classic mentioned by Horace. Johnson himself is now entering his fourth. What explains the stamina of his reputation? Why do skeptical and restless readers, even more than docile and traditional ones, develop a life-long passion for his writing? The relevance of his radical power continues to surprise. Of all authors in English not regarded chiefly as poets or novelists, Johnson remains the most popular and most profound. And no other writer's life, in so far as it is known by fact and not fueled by speculation, has fascinated readers more.

His varied record as an author remains astonishing, hardly believable. He stands as one of a handful of superb poet-critics constantly read and consulted. The *Lives of the Poets* is widely regarded as the greatest single work of criticism in English. His moral writings, primarily in the *Rambler*, *Idler*, and *Adventurer*, depict a complex, modern ethical universe. His wit, uniting strength of mind with happiness of language, is quoted almost as often as Pope's work, which itself falls second only to Shakespeare's. Johnson's *conte philosophique* or fiction *Rasselas*, written in one week first to raise money for his ill mother and then to defray the cost of her burial, has never gone out of print. Translated into dozens of tongues, it sells thousands of copies every year. His *Dictionary* proves him the greatest lexicographer in English, or any language. Given the texts and scholarship available to him, his edition of Shakespeare permanently elevates Johnson in the ranks of all succeeding commentators and editors, who continue to draw on remarks in his *Preface* as well as on observations and notes attached to individual plays. The broad, brilliant imitations of the Roman satirist Juvenal, *London* and *The Vanity of Human Wishes*, offer trenchant social, political, and personal attacks, yet in the *Vanity* Johnson cuts satire short in order to create enduring wisdom literature. He distills Juvenal's bile and Pope's emetic into a bittersweet liquor. Possessing the verbal sharpness of Pope, as well as the moral outrage and scathing reductionism of Swift, Johnson foregoes exercising them fully. Instead, he turns them to a meditation on the inadequacy of any human spirit to meet its own case, be its own god.

Johnson is also one of the most intriguing and accurate of travel writers. *A Journey to the Western Islands of Scotland* forms the perfect companion to Boswell's *Tour*.

Sermons Johnson wrote still find hearing in services. The five volumes of the Hyde edition of his letters reflect his place in the highest company of either familiar or formal correspondents. The twenty-seven *Parliamentary Debates*, almost a half million words, reveal Johnson as an acute political journalist. He writes speeches that for decades everyone would credit to Pitt the Elder, Walpole, and others as model orations rivaling the best of ancient performances. Johnson translates the French version of Father Lobo's *Voyage to Abyssinia*, some of it *ex tempore* while propped up in bed, as well as later rendering part of Sallust into English. Working early in his life with the *Harleian Miscellany*, he becomes the cataloguer and annotator of some 35,000 titles from that extraordinary private collection. His tragedy *Irene*, performed in 1749 some twelve years after its composition, runs nine nights at a time when three recovered all costs.

"Goldsmith," he said, "was a man, who, whatever he wrote, did it better than any other man could do" (*Life*). Yet, what Johnson produced as a Latin epitaph for Goldsmith, a writer whose career and fame he secured by recognizing the genius latent in the manuscript of *The Vicar of Wakefield*—that Goldsmith left scarcely any style of writing untouched and touched nothing that he did not adorn—could serve as his own with more justice. Austen identifies Johnson as her favorite prose author—for contemporary poetry she remarks that she would not mind being called Mrs. George Crabbe, and Crabbe is, not coincidentally, another writer whose career Johnson promotes. A young Mary Wollstonecraft meets and admires Johnson (she invokes him often in her work). So does Frances Burney, and the admiration becomes mutual. Later in his life, at Oxford, he makes a toast to shock, "Here's to the next insurrection of the negroes in the West Indies," knowing that insurrections were murderous and bloody. Elsewhere he asks, "How is it that we hear the loudest *yelps* for liberty among the drivers of Negroes?" and writes a court brief in behalf of a man threatened with slavery to argue that slavery is illegal in Scotland. Johnson becomes a proto-abolitionist. In youth he considered law as a career. Later, in helping Robert Chambers compose the Vinerian law lectures, Johnson emerges as a significant if ghostly legal authority. "The law is the last result of human wisdom acting upon human experience for the benefit of the public." Oxford does not confer on him the degree L.L.D., but rather Doctor of Civil Law.

His learning—vast and varied, not restricted to literature and history—is comparable to Milton's or Coleridge's. Adam Smith would declare that "Johnson knew more books than any man alive," and Smith was no friend. Yet, Johnson writes a style open and accessible to the entire literate culture, now as well as then. His language stretches but doesn't baffle the mind. Citation, reference, and pedantry were in his day common and increasing, but he applies learning to the business of living more than to the display of knowledge. Aside from editorial work on Shakespeare and Crousaz's commentary on Pope's *Essay on Man*, his pages harbor few notes, all short.

By force of character and conversation, in reflection and repartee, as well as through the stunning gifts of Boswell—who spent fewer than 400 days in his company, not the years many suppose—Johnson becomes the subject of a brilliant biography, the enduring touchstone for that kind of writing. Among the first to realize that modern fiction would increasingly portray the fabric of daily life, his own conduct and work lay the groundwork for life writing that has strong affinities with the novel. Boswell the biographer learns much from Johnson.

Of all this any attentive or scholarly reader is probably aware. It is a precarious thing to propose, but if generations of readers in various walks of life continue to cherish his thought and language for more than cultural authority, clubable familiarity, and sound bites veneered with age ("trumping life with a quote," as Heaney puts it), those readers discover and return to him because they recognize in Johnson a refusal to narrow his focus, a desire to regard literature as a source of delight—"tediousness is the most fatal of all faults."

The unweathered appeal of his writing does not rest in providing refinement for learned journals or seminars any more than his own life acquires its lasting interest by offering a caricature of his person for a quip or cartoon. A strong, multi-dimensional individual invites caricature, and for contracted minds the temptation to reduce a larger figure becomes hard to resist. Every generation entertains its superficial Johnson, Great Cham, Ursa Major, High Church and Tory persona, its Macaulay-inspired way of cramming an eagle in a pigeon hole. As with all such tags, those applied to Johnson contain some truth, but accepted as the truth they are false.

The endless accumulation of details impervious either to a general consideration of persistent human concerns or to an allied interpretation of perennial literary debates is an undertaking Johnson actually detests. He belongs more to the common reader than to the common scholar. Common scholars realize this least. What he says of the reception of Gray's "Elegy" expresses his sentiment: "I rejoice to concur with the common reader, uncorrupted with literary prejudices." Johnson seems always to keep in mind that his reader might well be poor rather than rich (yet interested in learning and art), and employed in gainful business rather than research. To make Johnson the province of professors or the property of editors betrays his own efforts. His authorial aims are to increase happiness by rendering vivid a sober though entertaining account of human ethical motives, faults, and successes; to advocate reduction of undeserved inequality and injustice; and to engage both his audience and himself in a quest for virtue and self-knowledge. He values what can be put to use and for this reason admits, "the biographical part of literature is what I love most." It "gives us what comes near to ourselves, what we can turn to use," or, as he puts it in *Idler* 84, what is "most easily

applied to the purposes of life." Perhaps the advertisement to the *Lives of the Poets* sums it up best: "the honeſt desire of giving useful pleasure."

"QUID FACIAM?"

Johnson's achievement grew from the odyssey of his own self-examined life checkered by, as Aeschylus calls it, "what is fated." Tubercular infeċtion in infancy and early childhood left his face scarred for life, with sight and hearing both impaired. As a child or in adolescence (we do not know which), he suffered smallpox, which further disfigured him. Time in his father's bookshop, as well as early acquaintance with his cousin Cornelius Ford, secured precocious learning. But after thirteen months at Oxford, poverty forced him to leave. His only sibling, a brother, seems to have committed a serious, perhaps a capital offence, and then died young. (The only reference we have to him from Johnson comes years later in a single diary entry immediately following a prayer for their mother, who had juſt died: "The dream of my Brother I shall always remember.") As a young teacher founding his own school, Johnson failed financially, though he formed a life-long bond with one pupil, David Garrick, who later helped produce and aċted in *Irene*. Johnson's varied friendships tended to laſt, for he was loyal. Years later he ſtood at Garrick's grave during the funeral, as Richard Cumberland reported, "bathed in tears."

Depression hit Johnson hard in his early twenties and again in his mid fifties. He feared for his sanity, and there is clear evidence that soon after he left Oxford he seriously contemplated suicide. Boswell's biography largely leaves out this private fear and faċt. Johnson felt, during these two periods of his life, that rational self-control might disintegrate. He was experiencing mental dissociation and depression so severe that he might not recover. Later, Heſter Thrale said that in his diligent ſtudy of medicine he "had given particular attention to the diseases of the imagination, which he watched in himself with a solicitude deſtruċtive to his own peace, and intolerable to those he truſted" (*Anecdotes*). After completing more than a decade of gifted jobwork, much of it for the *Gentleman's Magazine*, he can, in retroſpeċt, be seen as one of the moſt famous anonymous authors in English. Lord Cheſterfield's promised patronage of the huge *Diċtionary* projeċt paid him nothing, but did prompt one of the moſt dignified and acerbic letters of retort in the language. Not until Johnson was forty did any significant work, *The Vanity of Human Wishes* and *Irene*, appear under his own name.

As a young man he was grateful to think that any woman might find him attraċtive, but his seventeen-year marriage, however devoted at times, was ſtrained and childless. Elizabeth Porter, twenty years his senior, died when he was forty-two, and he never remarried. His grief remained for years. "He that outlives a wife whom he has long loved, sees himself disjoined from the only mind that has the same hopes, and fears, and intereſt; from the only

companion with whom he has shared much good and evil; and with whom he could set his mind at liberty, to retrace the past or anticipate the future" (*Life*).

He struggled continually against what he identified as melancholy, escapism, procrastination, and guilt, exacerbated by what Hester Thrale called "vain hopes of performing impossibilities." "No disease of the imagination," claims Imlac in *Rasselas*, "is so difficult of cure as that which is complicated with the dread of guilt: fancy and conscience then act interchangeably upon us, and so often shift their places that the illusions of one are not distinguished from the dictates of the other." In middle age Johnson fought successfully— and certainly feared—incipient alcoholism. ("Abstinence is as easy to me as temperance would be difficult.") Beset by what has variously been diagnosed as Tourette's Syndrome, obsessive-compulsive disorder, or simply nervous tics that he could not suppress even in familiar company—Pope said these habits made the young Johnson "a sad spectacle," and they didn't improve—he later also suffered insomnia and acute loneliness. If he found some comfort in the church and in the belief that the crucifixion of Jesus redeems humankind, he also found no easy rest in religion but instead, often, a rebuke to his own habits. He rarely attended services, something for which he criticized Milton severely. Inner conflict characterized his inner life. One diary entry simply reads, "*Mens turbata*. This afternoon it snowed." Shortly before he died, he burned at least two quarto volumes of private writing. Some infrared reading of a long-buried London ash heap would reveal secret thoughts that he carefully recorded but then just as deliberately destroyed.

His own efforts at self-knowledge involve self-imposed guilt. "Know Thyself," written in 1772 after enlarging and correcting the *Dictionary*, speaks about "one punishment, for the most impenitent . . . I find myself still fettered to myself . . . my heart is illiterate, and my mind's strength an illusion. What then am I to do? Let my declining years go down to the dark? Or get myself together . . . and hurl myself at some task huge enough for a hero?" (original in Latin, trans. John Wain). As if he had not already performed several such tasks— but he was never satisfied with himself. His personal life presents a series of struggles that he does not always resolve but at least endures, often by humor, and by finding a way to endure he gives hope to anyone facing similar trials.

A MIND OF LARGE GENERAL POWERS

In conversation he can "talk for victory" and vie with opponents for the last word, but his essays rarely take the vantage of personal superiority. While articulated in an uncommonly superior way, their structure grows from a felt moral commonality. The *Rambler* essays engage generation after generation of readers because their author has read then corrected his own reading by experience, because he continues to learn and correct apparently even

as he writes, turning on himself, and because he grapples with difficulties unfolding on the page that prove as hard for him to resolve as for his readers. He becomes a sympathetic though persistent and tough-minded inquisitor, interrogating others and at the same time asking himself if the critical reflections and ethical judgments by which one lives possess that quality without which all else—learning, wealth, prizes, degrees, privilege—becomes empty chatter or, as he calls it, cant. That quality is hard to define, but if any single word represents it, perhaps the best choice is *honesty*, including being honest with one's self. The desire to achieve this quality—and it must be achieved, any dolt can express an opinion—he approximates in his thoughts on the *Lives of the Poets*, the critical and biographical work culminating his career and drawing on almost every other kind of writing he practiced. He remarks in April 1779 that he was composing the *Lives* "I hope in such a manner, as may tend to the promotion of Piety." By this he means not cultivating religious thought alone, or even primarily religious devotion, but family experiences, scholarly learning, artistic creativity, civic responsibility, and personal integrity, all dedicated toward living life ethically, not by receipt but by trial and effort. Such honesty is a form of modern heroism.

Johnson's honesty, coming from observation, reading, and painful self-correction, is literary (expressed in language drawn in part from reading), religious, and traditional, but also experiential and at times remarkably uneasy about tradition. As it was for the Royal Society, the general motto of the *Rambler*, from Horace, is "take nothing on authority," *Nullius addictus jurare in verba magistri.* Characteristically, Johnson in the *Life of Dryden* later remarks, "Reason wants not Horace to support it." Even an authority warning against authority is no genuine argument against—or for—authority. Johnson recognizes a changed world in which force, wealth, and station, while powerful and at times commanding deference, can no longer stand unchallenged. They must pass tests of empirical scrutiny or else perish: "We have done with patronage." "No man was ever great by imitation." "Knowledge is more than equivalent to force." His own *Irene* helps to persuade him that imperial tragedy has little future on the stage. He rejects the critically revered dramatic unities of time and place. For him, the heroic ceases to mean prowess in arms and romance, exploits in sex and violence. Instead, it points to the individual, independent mind attempting to renovate known truths, establish new knowledge, and improve personal and institutional conduct.

Yet, more than renovating known truths, Johnson's thought unearths private truths about ourselves we would rather not face, exposes the evasions we practice, and adds this twist: the more sophisticated and resourceful we are, then the more elaborate, successful, and even pleasing are the self-delusions we practice. The benevolent, wise, benign, and thoroughly mad Astronomer in *Rasselas*, one of the most psychologically compelling characters in English fiction—he might by another name be plucked from

the pages of Dickens—demonstrates this humanely analytic power of Johnson's writing, but only if we realize that the story is about ourselves. Thankfully, by the end of the tale, the Astronomer appears at least partially rehabilitated by the friendship, conversation, and support of Nekayah, Pekuah, Rasselas, and Imlac.

In many statements Johnson advocates reason, but he never discounts the inadequacy of reason, riven with error and punctuated by mortality, to meet its own predicament. Errors of government and war, errors of intelligence, errors of parenting, errors of filial duty, errors of ingratitude and loyalty alike, errors of temptation to power or despair—these he has experienced intimately, and they become his theme from "The Young Author" through *The Vanity of Human Wishes*, the moral essays, and *Rasselas*. The most common phrase in his poetry comprises but two words: "in vain." As if this inadequacy were not enough, something worse intervenes. The world rewards genial mediocrity with a comfortable place, or higher, more regularly than it recognizes merit that has only merit to recommend itself. Without personal favor, prejudicial group support, financial advantage, and concerted networks of advancement—all of which average talent frequently enjoys—superior accomplishment finds it hard even to appear equal. Furthermore, such accomplishment raises resentment, often seems a rebuke (because occasionally it is), and plants the seeds of envy: "Many need no other provocation to enmity than that they find themselves excelled."

Beyond the world of literature—formal literary study was just beginning to shape itself into a particular, professional branch of knowledge that would, for better or worse, increasingly be associated less with the older sense of literature or letters as all knowledge conveyed in language and more with individual artistic expression and critical opinion—Johnson actively pursues interests in chemistry, agriculture, commerce, manufacturing, navigation, and technology. He writes prefaces and advertisements for books on, among other subjects, geography, trigonometry, medicine, geometry, and foreign trade. He studies medical diagnoses and advances. A main motive for his travel to the extremities of Scotland, then considered remote and primitive, is intense curiosity about an oral culture barely surviving. He concludes that he has arrived too late to witness its vitality. Johnson grasps the place and often unfair fate of indigenous populations and, despite his opposition to the American Revolution (urged by his close friend Henry Thrale, a member of parliament, to write against it), he is of no imperial mind. *Idler* 81 for Saturday, 3 November 1759, excoriates Europeans, and for their treatment of native North Americans calls both the French and English "the sons of rapacity." White settlers and their armies are fast turning a missionary religion into hypocrisy. One of Johnson's political pamphlets, *Thoughts on the Late Transactions Respecting Falkland's Islands*, meditates how frequently and with what facile calculation many leaders urge war, and how readily many unthinking citizens follow them.

Readers perusing the full run of *Ramblers* may be surprised to see how many he devotes to marriage, courtship, and domestic affairs, presenting, for his time, a surprisingly even-handed treatment of gender. In Johnson's characters and personae there is no particular distribution of wisdom between the sexes. If Imlac seems wise (and a little weary), Nekayah can be wise, too, yet fresh. Johnson chides Milton for "something like a Turkish contempt of females, as subordinate and inferior beings. . . . He thought woman made only for obedience, and man only for rebellion." Johnson notes caustically that Milton "diligently sustained" the "superiority of Adam" over Eve, both "before and after the Fall."

Anyone who claims a new angle on Johnson must temper self-advertisement with an incalculable debt to generations of writers and teachers who have worked to present him fully. The task, then, is not so much to reveal aspects of Johnson that no one has ever recognized—that verges on arrogance. The difficulty is to keep in play and give to active memory a comprehensive account of all his thought. Few have done this. It is difficult for at least two related reasons: first, the restless fertility and surprisingly unorthodox nature of that thought—surprising even to Johnsonian specialists—enmeshed, as many of its particulars are, in a world that at times seems distant and alien, at other times weirdly familiar; and, second, the resulting temptation to simplify and reduce Johnson's thought, to domesticate and label it, compounded by the inevitable process of intellectual amnesia that infects humanistic more than scientific learning.

Such a fragile hold on collective learning possessed by any generation Johnson respects and emphasizes. "Men more frequently require to be reminded than informed." Or, "No place affords a more striking conviction of the vanity of human hopes than a public library." In facing rather than finessing or denying these facts, he attains impersonal strength—strength of intellect, not personality—and this establishes his paradoxical authority. Paradoxical, because his authority is, in the end, not personal, but based on an extraordinary ability to see, admit, and express objectively the complex process of human reality, of the individual inner life confronting a global presence at times so discomfiting or, at the least, so relatively impervious to any one person's existence, that we spend much of life alternately seeking and rejecting that reality in, as Frost phrases it, "a lover's quarrel with the world." Johnson's admiration of Shakespeare and his explanation for that playwright's continued popularity rest on Shakespeare's artistic adherence to this broader reality, reality perceived imaginatively yet without illusion. Shakespeare presents "the stability of truth." His dialogue "seems scarce to claim the merit of fiction," and "even where the agency is supernatural the dialogue is level with life."

To apprehend such an encompassing reality and then to make sense of it from the standpoint of almost any compartment of knowledge is rare. It does not characterize

the mind that specializes, however brilliantly, in one field because it can never hope to excel in any other. Rather, it has a capacity to turn intelligence almost anywhere. So, in the *Life of Cowley,* Johnson does not define genius as it's usually understood—an individual of supreme gifts in one career or endeavor. Instead, "The *true* genius is a mind of large general powers, *accidentally* determined to some particular direction" (emphasis added). Such a mind could pursue myriad other directions with distinction.

It is, mostly, a lost art of judicious criticism carefully to balance positive qualities of a writer against flawed or deficient ones. Yet, every critic who exercises this (Johnson on Shakespeare, Coleridge on Wordsworth) realizes that here there is no immunity: *all* writing is subject to such an assay, a conclusion expressed by the oldest of critical proverbs, even Homer nods. "For faults and defects every work of man must have," says Johnson of *Paradise Lost*, and "it is the business of impartial criticism to discover" them. A fully disinterested criticism, which does not exist except as an ideal approached asymptotically, though an ideal worthy of emulation rather than of sophistical scorn, will look at every detail and will suspect, then recognize, and finally excoriate, as best it can, its own pre-judgment. Prejudice is present at the outset of every critical act.

We sometimes are by wishful affinity and identification seduced into patching over the cracks in our idols. Johnson makes some summary judgments that betray a lack of imagination and prescience. His dismissive verdict on *Tristram Shandy* is one example. The violent preference he expresses for Richardson over Fielding reveals something almost prudish. Few critics berate Shakespeare for puns, yet Johnson does so severely. His impatience forecloses appreciation of *Lycidas* and of the pastoral mode generally. His understanding and rejection of Hume as an atheist is inaccurate, and this misconception colors his entire approach to Hume's thought. Johnson usually belittles romances as fantastic, even corrupting, but he cannot "cure" his own long-time addiction to them, and romance imagery often animates his writing, for example, at the beginning of *The Vanity of Human Wishes*. The *Life of Milton* is at times patently unfair. Johnson's initial letter to Hester Thrale on hearing about her marriage to Gabriel Piozzi is harsh and without sympathy. (He makes amends, as he usually does, this time in another letter four days later.) Johnson realizes that Burke thinks more deeply in judgment and in a more complex manner than he does about many matters and all political ones. Burke is the only person he declines to debate. *Taxation No Tyranny* seems child's play next to Burke's *On Conciliation with the Colonies*. Johnson thinks it takes more artistic imagination to animate and imitate the complexity and cellular structure of reality than it does to create fantasy. ("The basis of all excellence is truth.") But were he alive in a later century he might look with interest on the creations of Lear, Carroll, Clarke, Bradbury, Stapledon, Tolkien, Lessing, and Pullman.

LANGUAGE ALLIED TO LIFE AND MANNERS

Johnson realizes that mundane language will not conjure up reality or lived experience with interest or credibility. Such usage only deepens verbal ruts. Yet, he grasps that no convention can simply be ignored. The ruts may be avoided but not the road. The admixture of convention with innovation, the avoidance of stock phrases coupled with the ingenious neologism, by these the language is preserved and refreshed. The *Dictionary* is in actuality the work of many hands; the examples that Johnson selects from "the best writers" evince his predilection for usage that marries the common and familiarly accepted with the newly normative drawn from authors of special talent. Like Chaucer before him (Johnson once proposed a life of Chaucer and an edition of all his writing), he understands that language cannot be fixed; it alters as common usage alters but also becomes a sharper medium through which to see the world when resourceful writers both listen to the crowd and have its ear. For that reason he turns to those writers as authorities and, by doing so, vicariously makes himself one. Shakespeare employs more words than any other poet; Milton comes second; Milton collected three volumes of notes for a Latin dictionary; Johnson wrote a two-volume folio one of English; Coleridge was the inspiring grandfather of the *Oxford English Dictionary* (his grandson was its first editor). It is more rare than commonly assumed for poets and critics to consider works, words, and world fully in concert.

Above all, Johnson keeps in mind and heart the paramount weight of common human experience. If class, gender, race, or privilege create divisions in national or global society, and if those divisions are accepted by habit tacitly, or by oppression unwillingly, then common humanity—and justice, even truth—become driven asunder, too. Once separated and divided, interests tend to polarize, self-magnify, and repel by increasing degrees. The common is lost in favor of a partial good that to its limited participants and factions seems greater. As a moralist, Johnson knows few compeers. His early illness, poverty, and relative obscurity taught lessons no syllabus could secure, no monograph enhance, no theory magnify.

Because the arts can, at their best, not only express but actively create and extend sympathy and the evolution of a humane spirit, and because they are not quantitative, repeatable, and iterative, not "demonstrative and scientific," their practice attains an amalgam of thought, feeling, intelligence, and experience unobtainable in science, and approximated only abstractly in social science. Yet, Johnson, championing this unique strength of the arts—of theater, poetry, music, fiction, and visual representation—also knows that, concomitantly, the arts cannot eject pretense, posturing, pandering, gossip, and envy. He has the courage to realize that, over time, the self-interested qualities of the arts, and of artists and critics, can subvert their own production. Fame may accompany

high mediocrity for a few decades, but what survives a few lifetimes or centuries does not begin by thinking foremost of current trends or levers of publicity. Coteries die, and the opinions of cliques dissipate.

He believes, passionately, in human progress. As a moralist he could remark that the cure for human ills is more palliative than radical, and that to keep humankind in a middle state and prevent it from sliding downward was about as much as could be expected. But when examining history and institutions he insists that permanent, collective gains are actual. Admiring Shakespeare, Johnson yet talks of "the barbarity" of Queen Elizabeth's age, which cannot extenuate how Shakespeare "sacrifices virtue to convenience." Petrarch's age is "rude and uncultivated." The manners of the mid-seventeenth century "were so tinged with superstition" (*Cowley*). Johnson states that the war in heaven found in *Paradise Lost* "is, I believe, the favorite of children, and gradually neglected as knowledge is increased." In *A Journey* he praises Thomas Braidwood's school in Edinburgh for the deaf and dumb and reflects, "It was pleasing to see one of the most desperate of human calamities capable of so much help: whatever enlarges hope, will exalt courage; after having seen the deaf taught arithmetic, who would be afraid to cultivate the Hebrides?"

Johnson puts his belief directly: the duty of a writer is to make the world better. *How* that is to be done, exactly along what lines, he never prescribes. There is no system. Criticizing Shakespeare for lack of moral care, he yet admits, "he that thinks reasonably must think morally." So, from Shakespeare's "works may be collected a system of civil and economical prudence," and "a system of social duty may be selected." Collected and selected but not prescribed. Johnson the moralist becomes Johnson the explorer, renovating known truths but pushing their limits and discovering through them previously uncharted paths that examine the self. He realizes that the comfort of knowing those truths grows treacherous without the ballast of self-knowledge. More than with the conditions of his life, difficult as they could be, his most heroic struggles are with himself. Hester Thrale noted the three books he would never tire of: *Robinson Crusoe*, *Pilgrim's Progress*, and *Don Quixote*, lonely figures, each surviving with belief in something larger than the self, but each beset by loss, doubt, even delusions.

Despite his prizing of general truths and regard for what he called "the common reader," Johnson does not eschew archival scholarship if it serves a larger, meaningful interpretive framework. He ransacks sources for whatever he writes, particularly evident in the *Lives*. When younger, he subtitles the Introduction to the *Harleian Miscellany* "An Essay on the Origin and Importance of Small Tracts and Fugitive Pieces." His recall of writers is so exact and exacting that John Hawkesworth confesses to him, "You have a memory that would convict any author of plagiarism in any court of literature in the world." While Johnson rejects detailed scholarship simply as an end in itself,

he contends that minute learning can be turned to conditions of "the living world." In short, knowledge actively invested with a degree of relevance will produce most value. What is desired is "the accuracy of a learned work" coupled with "the facility of a popular" one (*Cowley*).

THE CHOICE OF LIFE

A main endeavor of Johnson's writing tests the antinomies of the moral imagination. (Burke first uses the phrase "moral imagination" a half dozen years after his friend dies.) These antinomies are not flat contradictions or oppositions. More like Blake's *contraries*, they exhibit a vacillating difference of conviction between activities and positions that are equally plausible and equally necessary, and whose tension must therefore be regulated because it can never be settled. No hope germinates or survives without imagination, but some hopes are vain, some grow inflated, even harmful. Progress depends on discontent, but gnawing dissatisfaction steals away happiness. Cowley conjectured that he'd be happier if he removed to an island in the Americas. He "forgot, in the vehemence of desire, that solitude and quiet owe their pleasures to those miseries, which he was so studious to obviate; for such are the vicissitudes of the world, through all its parts, that day and night, labour and rest, hurry and retirement, endear each other; such are the changes that keep the mind in action; we desire, we pursue, we obtain, we are satiated; we desire something else, and begin a new pursuit" (*Rambler* 6). These antinomies mark the structure of *The Vanity of Human Wishes* where, repeatedly, at crucial junctures, verse paragraphs begin, "Nor," "But," "Yet." In "Reflections on the Present State of Literature," Johnson candidly remarks, "Whatever may be the cause of happiness, may be likewise made the cause of misery." In *Rasselas* Nekayah advises her brother, "Flatter not yourself with contrarieties of pleasure. Of the blessings set before you, make your choice and be content. . . . No man can at the same time fill his cup from the source and from the mouth of the Nile."

Yet, exploring these moral antinomies presents no closure. The concluding chapter of *Rasselas* is "The Conclusion in Which Nothing Is Concluded." Even on some matters in which Johnson proclaims, with barely concealed scorn, that tendencies of the imagination can and ought to be kept in check, he later finds himself differing from his own earlier conviction, or giving into those tendencies himself. In *Idler* 11 Johnson excoriates the idea that genius flows or is impeded by the seasons as if it were a blindly animate process, like sap rising in the sugar maple, and warns that to believe this "is no less dangerous, than to tell children of bugbears and goblins. . . . This distinction of seasons is produced only by imagination operating on luxury. . . . He that shall . . . exert his virtues, will soon

make himself superior to the seasons." Milton's vigor of composition surfacing only half the year, Johnson, again on his high horse, denigrates by saying, "This dependence of the soul upon the seasons, those temporary and periodical ebbs and flows of intellect, may, I suppose, justly be derided as the fumes of vain imagination" (*Milton*). Johnson then quotes—of all texts!—Burton's *Anatomy of Melancholy*, to the effect that the skies, stars, and heavens may exert influence on us but "a wise man may resist them." Then, in 1781, in a letter tellingly filled with Miltonic echoes, Johnson admits, "I thought myself above assistance or obstruction from the seasons, but find the autumnal blasts sharp and nipping and the fading world an uncomfortable prospect."

The benevolent Astronomer in *Rasselas* was mad for believing that he controlled the seasons, rain, and sun, but Johnson himself finally admits that to insist the reverse, that we can control, completely, the effect of the seasons on us, is itself an antinomy of imaginative folly, too. What he says in *Rambler* 184 about the world being under the total guidance of a benevolent power, where apparent evil contributes to the larger calculus of good, he virtually mocks, more than two decades later, in comments on Pope's *Essay on Man*. One of Johnson's favorite *Rambler* themes is how the life of an author almost inevitably differs from the wisdom of that author's works. "The teachers of morality," says Imlac, "discourse like angels, but they live like men."

The extent to which Johnson yokes or puts in close proximity the words "disease," "dangerous," "restless," "hunger," "vain," and "imagination" is extraordinary. Yet, he says in full praise, "Milton had that which rarely fell to the lot of any man—an unbounded imagination, with a store of knowledge equal to all its calls" (*JM* II, 165). The balance must always be adjusted, the exception found. Even in loyal friendship lurks deception: "Friendship has no tendency to secure veracity" (*Pope*). Richard Savage, Johnson observes, "lulled his imagination with . . . ideal opiates," but later warns, "nor will a wise man presume to say, 'Had I been in Savage's condition, I should have lived, or written, better than Savage.'"

"Where then shall Hope and Fear their objects find?" How can anyone settle these antinomies? They resist resolution. Their moral tension remains, and all responses are, if relied on blindly, doubtful. Some are destructive. Imlac advises Nekayah, "Do not entangle your mind by irrevocable determinations." For Johnson, faith is one answer ("Nor deem religion vain"), but it is neither easy nor comfortable. Faust finally says, *Verweile doch*! Yet in Johnson the cry never comes; the restless desire may be for knowledge, it may be for vanity, fame, sex, power—for *any* wish or desire, but it never ceases. Johnson's deeper psychological theme identifies a modern Faust who cannot even find a Mephistopheles with whom to bargain. This is a worse predicament. Collectively, his protagonists, examples, and personae seek anything that *can* be desired, illustrated particularly in *Vanity* and *Rasselas*. And yet, not to desire is, for all but the

cloistered adepts of a rare enlightenment, inhuman and impossible. Rasselas lives in an apparent utopia: "All the diversities of the world were brought together . . . and its evils extracted and excluded"—"Every desire was immediately granted"—the *happy valley*. (The adverb *immediately* is not so innocent or inviting as it seems.) Why would the prince grow restless and wish to escape its walls and mountains? The entire world he must use as a comparison with his incomparable state waits outside. It is usually not recalled that Imlac at first tries to deter Rasselas from leaving. When, some years later, the prince returns, having witnessed so many moral antinomies in others, he yet seems unable to escape his own: we look ahead to a time when "he could never fix the limits of his dominion, and was always adding to the number of his subjects." By what method is not mentioned. The antinomies of the moral imagination prove as hard to escape as the happy valley itself.

This consideration of the bind—at times the trap—that individuals, sects, and even whole nations ("by darling schemes oppress'd") create for themselves in negotiating the antinomies of the moral imagination makes all the more urgent its concomitant presence in Johnson's thought: the free agency of the human spirit, the effective power of individual resolution and hard work. By this free agency all advances in learning, science, technology, trade, and justice occur. Observing the determination of Rasselas to breach the walls of the happy valley, Imlac, rather than counseling despair, gives encouragement: "Few things are impossible to diligence and skill." Even the Astronomer seems able by efforts of his own will, assisted with aid and compassion from others, to disperse many of the thick mists clouding his reason.

If it is countered to this emphasis on will and benevolence that Johnson believes in social subordination, several things might be said. Yes, he does, though no society has yet *in practice* devised an order without some form of subordination, *de facto* if not *de jure*. These orders vary from the evil to the tolerable. Aside from deference to hereditary monarchy, moderated by the settlement of 1714, Johnson advocates little in the form of a system of subordination established by birth or wealth. He rejects the racism, sexism, and ethnic hatred practiced by many Europeans and Americans of his day and even now. He supports significant social and economic mobility. It is Boswell, defending race slavery and aristocratic privilege, who constantly brings up "subordination." Boswell often injects it as Johnson's "favorite topic." The implied reader of *The Vanity of Human Wishes*, the moral essays, *Rasselas*, and the *Lives of the Poets* remains the common reader, the reader whose only qualification is literacy. Johnson's intended audience owns no special privilege. His sympathy favors no station. He gives to the poor and houses the homeless, several under his own roof for years. Despite his criticism of religious poetry, Hester Thrale relates, "When he would try to repeat the celebrated *Ecclesiastica pro Mortuis* . . . beginning *Dies irae, Dies illa*, he could never pass the stanza ending thus,

Tantus labor not sit cassus [May such suffering be not *in vain*], without bursting into a flood of tears."

Dedicated in gratitude to the memory of Mary Hyde Eccles. For her generation and for posterity she cared intellectually, materially, and personally to strengthen and support a central arch of civilization: learning, libraries, and books, the presentation and preservation of original texts and manuscripts. Few eighteenth-century scholars of academic reputation match the quality of her research, archival discoveries, and publications. Her critical work prompts the grateful thanks of scholars and readers. Her personal and intellectual encouragement endeared her to every life she touched.

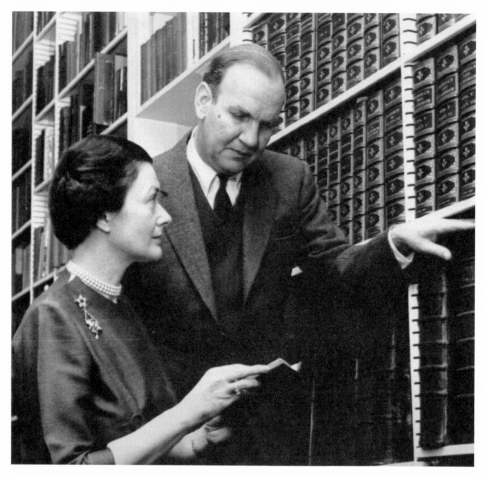

Donald and Mary Hyde in their library at Four Oaks Farm. Photograph. [ca. 1958].
MS Hyde 98 (2010)

The Hydes Collect Johnson

William Zachs

In all collections, Sir, the desire of augmenting it grows stronger in proportion to the advance in acquisition.

Samuel Johnson on the library of Sir Thomas Beauclerk.
The Life of Samuel Johnson, LL.D. iv.105
(Hill-Powell edition)

OF EXHIBITIONS AND ACQUISITIONS

One hundred years ago, on 18 September 1909, the Grolier Club of New York hosted a major exhibition to mark the bicentenary of Samuel Johnson's birth. This exhibition showcased a nearly complete group of first editions of Johnson's poetical and prose works, a selection of his manuscripts, association copies, and a large number of engraved portraits. Several leading bookmen of the era contributed items, including R. B. Adam, J. P. Morgan, A. Edward Newton, A. S. W. Rosenbach, and Harry E. Widener.[1]

Donald and Mary Hyde, from whose collection the display items in the present exhibition have been selected, were influenced by what this earlier exhibition had contained—and by what it had not. The Hydes knew the Grolier *Catalogue* well and used it as a point of reference when evaluating opportunities to acquire Johnsonian items. A number of the books and manuscripts featured in that Grolier display are now in the present exhibition, including Johnson's *Political Tracts* inscribed "From the Authour to Mr. Boswell" (item 92). Others are to be found on the shelves of the Hyde Collection at Houghton.

1 *Catalogue of an Exhibition Commemorative of the Bicentenary of the Birth of Samuel Johnson, 1709-1909* (New York: De Vinne Press, 1909). The archive of the Grolier Club provides detailed information about the organization of the exhibition. Three other notable lenders were Winston H. Hagen, Harry B. Smith, and Chauncey B. Tinker.

In the foreword to the Grolier *Catalogue* the organizing committee noted with regret that two Johnson works could not be obtained—the *Letter to Lord Chesterfield* and the *Conversation with King George III*—both rarities published by Boswell in 1790. The Hydes were to acquire two copies of the *Letter* (item 35) and one of the *Conversation*. However, one other item, noted with "pleasure" by the exhibition committee, and at the time thought unique, continued to elude the Hydes throughout their years of collecting. This was Johnson's *Prologue and Epilogue Spoken at the Opening of the Theatre in Drury-Lane*, 1747, lent by Dr. Rosenbach.[2]

The Hydes also studied carefully the catalogue of the 1934 Free Library of Philadelphia *Exhibition of Original Manuscripts, Autograph Letters and Books of and relating to Dr. Samuel Johnson*, which commemorated the 150th anniversary of Johnson's death. All the thirty-five books and manuscripts in this exhibition were owned by Rosenbach. He had sold many of them to the collector A. Edward Newton. Over several decades the Hydes managed to obtain a number of these items—including the manuscript draft of the dedication to Queen Charlotte for Hoole's translation of Tasso's *Jerusalem Delivered* (item 83).

Donald and Mary Hyde were married in September 1939. They moved from Detroit to New York a year later, and bought a farm near Somerville, New Jersey, which they named Four Oaks. Over the next thirty years they amassed a Johnson collection more impressive in quality and broader in scope than the Grolier and Rosenbach displays put together. A series of three acquisitions of increasing significance during the 1940s secured the Hydes' reputation as the foremost collectors of Johnson and his circle.

The first of these purchases was a number of Johnsonian items from the 1941 A. Edward Newton auctions—black-tie events that took place soon after the Hydes' arrival in New York. They acquired a volume of letters and petitions compiled by Johnson on behalf of the condemned prisoner William Dodd for $850, the manuscript of Johnson's *Consideration on Trapp's Sermons* for $275, the copy of Boswell's *Journal of a Tour to the Hebrides* given to his son Alexander for $65, as well as Johnson's silver teapot for $650 (item 48).[3]

Next, between 1945 and 1948, they placed themselves in a position to extract prime Johnsonian manuscript material costing $34,000 from Colonel Ralph H. Isham's re-markable troves of Boswelliana, the first of which had come from Malahide Castle in

2 A. S. W. Rosenbach, one of the great American dealers of the first half of the twentieth century, apparently was never willing to part with his copy, now in the Rosenbach Museum and Library. Harvard's copy of the *Prologue*, now one of six known, is part of the Evert Jansen Wendell bequest of 1918.

3 Rosenbach Company Invoice, 17 May 1941; added to the $650 hammer price was a ten percent commission. MS Hyde 98 (237).

Ireland in the 1920s, the second discovered at Fettercairn House in Scotland a decade later. Donald Hyde had provided legal advice and loan guarantees to Isham in the latter phases of this complex acquisition, and in July 1949 he helped Isham to negotiate the sale of the rest of the collection to Yale for $450,000.[4] Among the Hydes' most important purchases from Isham were 119 Johnson letters and his early diary notes (items 10 and 11) for $14,000, the manuscripts of the *Vanity of Human Wishes* (item 22) and Johnson's translation of Sallust's "Catiline" for $10,000, and Boswell's "Book of Company at Auchinleck" for $3,500 (item 59).

Finally, in the autumn of 1948, after a long negotiation, the Hydes acquired the R. B. Adam Collection for $157,500. (The asking price was $175,000.) In this deal they out-manoeuvred both Yale and the University of Rochester, where the Adam Collection had been deposited. Among this collection—described in the four-volume *R.B. Adam Library relating to Dr Samuel Johnson and his Era* (1929-30)—were 230 Johnson letters, as well as the only substantial surviving letter written by Boswell to Johnson (3 March 1772; item 51), along with other important printed and manuscript material relating to Johnson, Boswell, and the period generally. Arthur A. Houghton Jr., whom the Hydes looked up to as a supreme collector, and who had ushered them into the social world of book collecting, called the R. B. Adam acquisition a "great purchase." Donald Hyde told the larger-than-life Colonel Isham, "We like to think we . . . have done for the Doctor [Johnson] the same kind of thing, in a much lesser way, that you have done for Boswell."[5]

The Hydes' aspirations met with some measure of success and public recognition when in September 1959, fifty years after the Grolier exhibition, the Pierpont Morgan Library held another major Johnson exhibition in America, marking the 250th anniversary of Johnson's birth. Nearly half of the 130 items exhibited—books, manuscripts, letters, portraits, and other Johnsonian materials—were from the Hydes' library. The other major lenders were the Morgan itself, Yale, and the Hydes' good friend and fellow Johnson collector Herman W. "Fritz" Liebert of Yale University.[6] Many of the items in this present exhibition have not been on public display since then.

4 The Hydes engaged David Buchanan, the son of the Edinburgh lawyer who acted for Colonel Isham in Scotland, to write *The Treasure of Auchinleck. The Story of the Boswell Papers* (New York: McGraw-Hill, 1974). Apppendix V (pp. 342-48) lists all the Boswell papers bought by the Hydes from Isham, as well as material the Colonel sold to others (including 110 leaves of the *Life of Johnson* manuscript to Dr. Rosenbach, subsequently sold to Arthur A. Houghton Jr. and now at Harvard).

5 Letter (copy), Donald Hyde to Arthur A. Houghton Jr., 15 September 1948, MS Hyde 98 (859); letter (copy) Donald Hyde to Colonel Ralph H. Isham, 21 October 1948, MS Hyde 98 (884).

6 *Samuel Johnson, LL.D. (1709-1784). An Exhibition of First Editions, Manuscripts, Letters, and Portraits to Commemorate the 250th Anniversary of his Birth, and the 200th Anniversary of the Publication of*

THE FOUR OAKS LIBRARY

To house their growing collection, the Hydes added to their home a purpose-built extension which opened in April 1949. The Four Oaks Library—with Johnson, Boswell and Hester Thrale at its core—established the Hydes' place among the most serious book collectors of the period. This had a certain social cachet attached to it: the Hydes' collection was a somewhat unusual topic in the *New Yorker's* "Talk of the Town" pages in March 1958. Headed "Johnsonian," the article began: "Let us pause, in this day of science resurgent, to note that the humanities are still with us, and that the greatest Samuel Johnson collection is right in the heart of New Jersey beagling-and-foxhunting country, at the Somerville dairy farm of Donald F. and Mary Hyde."[7]

The *New Yorker* had distilled the Hydes' own account of the growth of their collection, printed in the Autumn 1955 *Book Collector*. The story was expanded in the privately printed *Four Oaks Library* of 1967. The three lead articles in the volume—Robert F. Metzdorf's "Samuel Johnson," Charles Ryskamp's "James Boswell," and James L. Clifford's "Mrs. Thrale Piozzi"—described the main elements of the collection that came to Harvard in the spring of 2004. The *Four Oaks Library* volume became, in effect, a memorial to Donald Hyde, who died in February 1966 as the book was nearing completion.[8]

One defining characteristic in the formation of the Four Oaks Library (as the Hydes themselves had noted in the *Book Collector* article) was that it was their collaborative effort. Further development of the collection might have ended with Donald Hyde's death. But Mary was herself a highly educated and acquisitive collector. Moreover, it was no secret that the bulk of their wealth had been hers to begin with. She had the time, the energy, and the scholarly sensibility to carry on their project. For some thirty-five years—until her own death in August 2003—Mary continued to collect, despite facing considerable competition both from institutions building collections of Johnson

Rasselas, *September 22 – November 28, 1959* (New York: Pierpont Morgan Library, 1959). Lenders of single items included such notable collectors and scholars as Yale professor Chauncey B. Tinker, Arthur A. Houghton Jr., Columbia professor and author of *Young Samuel Johnson* (1955) James L. Clifford, and University of Rochester librarian Robert F. Metzdorf.

7 *New Yorker*, 22 March 1958, by Geoffrey T. Hellman. Thanks to Jon Michaud of the *New Yorker* for identifying the author as Hellman, whose archive is at New York University. The *New Yorker* also ran a review notice of the Morgan exhibition in the 17 October 1959 issue.

8 Another published "memorial" was *Eighteenth-Century Studies in Honor of Donald F. Hyde*, edited by Houghton director W. H. Bond (New York: Grolier Club, 1970). Three other articles in the *Four Oaks Library* volume describe collections which have also come to Harvard: Hugh Amory's "Henry Fielding," Metzdorf's "Other 18th-Century Authors," and Geoffrey Agnew's "18th-Century Pictures."

(and the eighteenth century more broadly), as well as from other individual Johnson collectors (Fritz Liebert, Loren Rothschild, Paula Peyraud, Gerald Goldberg, and Paul Ruxin, to name a few). Mary left her own distinctive mark on the Four Oaks Library, on the Johnsonian community, and on the book-collecting world.

The Hydes believed that their unique collection of research materials created an obligation to scholars. Their response was to make the Four Oaks Library a center for Johnsonian studies and a model for good practice at a private research library. They understood what Johnson meant when he remarked that "a man will turn over half a library to make one book" (*Life* ii. 344). They invested considerable time, energy, and money in cataloguing and indexing the entire collection: for example, some thirty thousand index cards referenced people, places, and events mentioned in their manuscript material. Until Mary's death, almost every scholar who worked on Johnson, Boswell, and Mrs. Thrale either corresponded with them or came to the Four Oaks Library (some virtually moving in): R. W. Chapman, L. F. Powell, W. Jackson Bate, James Clifford, David Fleeman, Bruce Redford, and Gordon Turnbull, amid scores of others.

While Mary continued to buy important books and manuscripts for the collection until her death, perhaps her most enduring legacy (philanthropy aside) is the list of scholarly publications directly associated with the eighteenth-century collections at the Four Oaks Library. Notable book-length productions include: the Yale Edition of Johnson's *Diaries, Prayers, and Annals* (1958), edited by E. L. McAdam with the assistance of the Hydes; Mary's own monograph, *The Impossible Friendship: Boswell and Mrs Thrale* (1972); and a study based on the journals of Hester Thrale, *The Thrales of Streatham Park* (1976). Other editions of manuscript material in the collection that are also of interest include *Boswell's Book of Company at Auchinleck* (1995), edited by Gordon Turnbull and Mary herself for presentation to the Roxburghe Club, as well as the numerous keepsakes produced for gatherings of the "Johnsonians"—a group of scholars, collectors, and librarians who meet annually to celebrate Johnson's birthday. There is also a substantial list of scholarly and popular articles written by the Hydes.[9]

Foremost among the works of scholarship associated with the Four Oaks Library stands the five-volume *Letters of Samuel Johnson* (1992–94), edited by Bruce Redford. Known as the Hyde Edition, the work supplanted Chapman's three-volume edition of 1952. This project represented the culmination of the Hydes' endeavors not only to acquire as many Johnson letters as possible but also to identify all of those in other collections.

9 Mary's Thrale books were first serialized in the *Harvard Library Bulletin*. Fifty years of Johnsonian gatherings and printed keepsakes are chronicled in *Johnsonian Celebrations* (1996). For a selection of articles, see *Mary Hyde Eccles: A Miscellany of Her Essays and Addresses*.

At the time of its bequest to Harvard, the Hyde Collection contained 746 Johnson letters, nearly half of the known total. More than 200 were acquired by Mary after Donald's death—usually one letter at a time. The sometimes unlikely ways in which these letters arrived at the Four Oaks Library make for stories in themselves. For example, Mary told of a woman, Frances Hooper of Chicago, who, having received a request from the Hydes for a photostat of her single Johnson letter, offered to give it to them in exchange for a cup of tea served from Johnson's silver teapot.[10]

Mary made one of her most exceptional purchases, the "Queeney Letters," in 1993. This archive consisted of 750 letters written to Hester Maria "Queeney" Thrale (Mrs. Thrale's eldest daughter who was nicknamed by Johnson, referencing the biblical Queen Esther). There were 32 letters from Johnson himself (first published in a heavily edited form in 1788), 367 letters from Mrs. Thrale, 51 letters from Fanny Burney, and 291 letters from "Queeney's" husband, Lord Keith. Mary acquired the collection through Bernard Quaritch Ltd. from the Earl of Shelbourne for £250,000. The Johnson letters to "Queeney" arrived in time to be incorporated into the Hyde Edition, which was then being prepared.

Mary's dedication to her collection is further illustrated by the purchase of the letter of introduction from Gilbert Walmsley (item 16), carried by Johnson and David Garrick, his friend and pupil, as they walked from Lichfield to London in 1737 to start their respective careers. Although not a Johnson letter, it was highly desirable as an early Johnsonian document. When it surfaced in 1998, Mary bought it without hesitation from the London dealer Simon Finch for £16,000.

THE HYDE ARCHIVE

Along with the Johnson collection, Mary Hyde Eccles—she had married David (Viscount) Eccles in 1984—bequeathed an extensive archive of personal papers to Harvard, which are designated MS Hyde 98. These materials detail the formation of the Hyde Collection over a sixty-five-year period and the scholarly uses to which it was put. They also reveal the wide range of personalities who inhabited the Hydes' world. The archive is organized into eight series, comprising 3,250 folders—tens of thousands of documents in all:

10 Letters (copies), Mary Hyde to Frances Hooper, 9 August 1959 and 16 January 1961; letter from Frances Hooper to Mary Hyde, 11 January 1961, MS Hyde 98 (853). The Johnson letter in question was to Mrs. Thrale, dated 10 October 1777.

I. Personal papers (including financial records and travel files)

II. Property files (including events held at Four Oaks Farm and library files)

III. Correspondence

IV. Clubs and organizations

V. Compositions and research (including material relating to the manuscripts and letters of Johnson)

VI. Visual material (including photographs)

VII. Papers of Donald Hyde (including documents relating to his role as Isham's legal advisor)

VIII. Papers of David (Viscount) Eccles.

MS Hyde 98 is a remarkably complete and revealing record.[11] At its heart lies an extensive correspondence. For more than half a century both Donald and Mary Hyde wrote and received thousands of letters—so many, in fact, that the total is as yet uncounted. They corresponded with book dealers, librarians, scholars, fellow collectors, family, friends, and with the descendants of some of the collected authors—notably Boswell and Mrs. Thrale.

To do justice to this archive would require a book-length study. Unfortunately, my familiarity with the material is less than complete. In what follows I can do little more than offer some less well-known information about the formation of the collection—mainly concerning dealers and librarians—to indicate the extent to which the archive tells stories beyond the ones the Hydes had already told.

11 A full listing of MS Hyde 98 is available online: http://nrs.harvard.edu/urn-3:FHCL. Hough:hou01787. While the bulk of the Hydes' papers is at Houghton, there are also materials at the Grolier Club, donated by Mary's niece Sally Bullard, mainly relating to Club excursions, found at: http://www.grolierclub.org/LibraryAMC.EcclesCollection.htm. Ms. Bullard also donated other general Hyde travel materials to Houghton. Before the papers arrived, a limited purging seems to have taken place relating to events such as Donald Hyde's death, and disagreements with such scholars as Frederick A. Pottle and David Fleeman. Moreover, the executors have retained tax returns and other papers connected with the on-going settlement of Mary Hyde Eccles' estate. Access restrictions (of 50 years from the date of the document), applied by the curators at Houghton, include correspondence and other papers relating to: 1. Four Oaks Farm staff, 2. Harvard University, 3. estate planning with legal advisors, and 4. club elections and finances. Finally, certain individuals have requested a restriction on their personal correspondence.

BOOK DEALERS—MABEL ZAHN AND MAGGS BROTHERS

The Hyde archive provides a picture of the book trade over a sixty-five-year period (1939-2003) and offers insights into the array of characters who sold books to the Hydes. In America their most important dealers included Dr. Rosenbach and his successor John Fleming, Mabel Zahn of the Philadelphia firm of Sessler, Goodspeed's in Boston, Scribner's and Seven Gables in New York. In Britain the Hydes bought from, among others, the firms of William H. Robinson, Martin Breslauer (before the move to New York), Maggs Brothers, Pickering & Chatto, Winifred Meyers, Peter Murray Hill, and Bernard Quaritch.

For anyone interested in collecting and in the economics of the book trade it is of considerable value to discover exactly how much things cost and to learn how the Hydes set about acquiring their books, manuscripts, portraits, and other Johnsonian material. The information the Hydes carefully preserved—correspondence (often on both sides), receipts and catalogue records—puts their activities in a context that reveals the ways collectors collect and dealers deal.

A case in point is the Hydes' correspondence with Mabel Zahn. This exchange demonstrates the positions of both sides in an uncertain market. For example, in May 1941 the Hydes hesitated over Zahn's offer of one page of the original manuscript of Johnson's *Dictionary*, priced at $1,650 (item 32). This item had sold twelve years earlier for $11,000 at the Jerome Kern sale (an auction remembered for the extraordinarily high prices achieved just before the 1929 Crash). There ensued a long negotiation that would ultimately bring the Hydes not only this rarity but six Johnson letters as well. For well over a year, Donald Hyde led the deal, knowing that there was little competition even for such choice items at the time. He wrote Zahn on 11 September 1942: "To be quite frank, I feel that the price you are asking is out of line with the current Johnson market. This does not mean that they are too high, for of course no one knows what things of that kind are worth. However, there are so many other things available at more favorable prices that naturally I will use any money that the Government doesn't take to buy them."[12] This material was too good to pass up, and an agreement was eventually reached, the Hydes paying $1,250 for the *Dictionary* manuscript and $1,595 for the six letters.[13]

Sometime later, Zahn, taking a cue from Hyde in the matter of "the current Johnson market," compiled a chart of prices of all the Johnson letters sold since 1923. Zahn summed up her thoughts in a letter of 14 October 1950 which accompanied the

12 Letter (copy), Donald Hyde to Mabel Zahn, 11 September 1942, MS Hyde 98 (615).

13 Receipt, 10 May 1946, MS Hyde 98 (159).

chart: "In the experience of dealers we of course digest these records as we go along and experience them in the sales and that becomes our mental equipment. It is salutary, however, to actually see the story and to understand how the larger economic picture plus the cycles of interests affect prices."[14] Over the years, many more books and manuscripts were bought from the firm of Sessler, with Mabel Zahn always at the center of the action.

Maggs Brothers was one obvious association for the Hydes to establish in Britain. Three folders of correspondence and receipts record this productive relationship, beginning in September 1947 and continuing into the late 1990s. Letters by Johnson, rare Johnsoniana, as well as Boswell and Thrale material, passed through Maggs en route to the Four Oaks Library. Two important Maggs catalogues (in 1952 and 1983) devoted to Johnson and his circle give a clear indication of the kind of material Maggs was able to acquire and sell to customers like the Hydes. Such catalogues have themselves become useful works of scholarly reference.[15]

Maggs' first major offer to the Hydes was a collection of six Johnson letters, Johnson's three-page draft of the Dedication to the Duke of Northumberland for John Hoole's translation of *Metastasio* (1767), and twenty-four further letters from the period with references to Johnson. The Hydes naturally wanted the first two, but they considered the price of £500 ($2,000 at the time) to be too high. They offered £375 ($1,500). Maggs explained that their cost had been £400 and asked for £410. A mark-up of 2.5 percent seemed reasonable; the Hydes agreed; and so began a productive relationship.[16]

Librarians—Randolph G. Adams, William A. Jackson, and Fritz Liebert

Before moving to New York in November 1940, the Hydes were encouraged in their collecting by Randolph G. Adams, the director of the Clements Library at the University of Michigan. He steered them towards literary books and put them off collecting western Americana. Adams was acting as a *soi-disant* "bibliographical counsellor" to Dr. Rosenbach for the A. Edward Newton sales, and Adams' father was the Newton

14 Letter, Mabel Zahn to Donald Hyde, 11 September 1942, MS Hyde 98 (615). The particular context for this inquiry was the hoped-for purchase of twenty-five Johnson letters owned by a Mr. Bergson, which the Hydes soon after acquired through Zahn for $3,900.

15 The 1952 catalogue was largely the work of Kenneth G. Maggs, while Donald D. Eddy contributed to the 1983 catalogue, much of whose material came from the Johnson collection of W. R. Batty.

16 Letters 23 September–4 November 1947 between Kenneth G. Maggs and Donald Hyde, MS Hyde 98 (996); receipt, 1 January 1948, MS Hyde 98 (216)

family lawyer. He first introduced the Hydes to Rosenbach, telling them on 12 February 1941: "he is the great man in the game and sooner or later you are going to need a talk with him."[17] Coming from an insider, Adams' remarks on the upcoming Newton sales gave the Hydes a sense of the complex machinations behind the book world: "Dr. R. is working hard to make the A. E. N. sale a success from the standpoint of the Newton family. When the Doctor goes sentimental (which is frequently) he goes all the way."[18]

Around the time of the Newton sales, Arthur A. Houghton Jr. introduced the Hydes to William A. Jackson, the first director of Harvard's rare book library. (Houghton Library opened in February 1942.) A highly respected scholar-bookman, Jackson became the most important librarian to advise the Hydes as collectors. He also cultivated their inclination to support research libraries and Harvard's in particular. It is not an overstatement to say that the Hydes' Johnson collection came to Harvard largely because of Jackson. Writing in 1964, Mary noted: "For over 20 years—with every book project we have undertaken—he has helped us, guided us, supported us—never let us down."[19] It was Jackson who directed the Hydes towards the leading British book dealers—dealers from whom Jackson had been buying on annual visits since before the Second World War. The Hydes returned these favors: they gave Jackson no less (and often more) than $1,000 annually for library purchases, they donated books—such as a collection of the poet Samuel Rogers in May 1950, and they served on the library's Visiting Committee for many years.

Jackson's death in October 1964 at the age of 59 came as a shock. It was a huge blow to the book world in general and to the Hydes in particular. The letters of condolence received by the Hydes themselves indicate the depth of the relationship. "Bill's death," Mary lamented, "has affected us more deeply than any other except our parents—and we can't seem to get hold of ourselves."[20]

Because of Jackson, it seemed certain that the Johnson collection would be destined for Harvard. Indeed, planning had begun in 1961 to create rooms at Houghton for the collection. Every Johnsonian book, manuscript, work of art, chair, and teapot had its designated place in the proposed Hyde Rooms. However, by the mid 1980s, the final disposition of the collection had begun to raise serious questions for Mary, causing speculation in the library, book collecting, and Johnsonian worlds. Her letter to Arthur A. Houghton Jr. of 14 June 1985 reveals that the Morgan Library stood to receive the

17 Letter from Randolph Adams to Mary Hyde, 12 February 1941, MS Hyde 98 (471).
18 Letter from Randolph Adams to Mary Hyde, 16 February 1941, MS Hyde 98 (471).
19 Letter from Mary Hyde to Louise Bates, 26 October 1964, MS Hyde 98 (890).
20 Ibid.

Johnson collection.[21] The intervention of Houghton himself, and of others closely associated with the Hydes and Harvard (including the Hydes' good friend and Harvard supporter Robert Graff and Houghton librarian William H. Bond), was one factor among many that would overturn this decision some years later and allow the original plan of Jackson, Arthur Houghton, and the Hydes to be realized. Letters in the extensive Hyde-Jackson and Hyde-Houghton correspondence, and in other parts of the archive, reveal the particulars of a story the progress of which led to Mary's bequest and to this present exhibition.

All but one item from the Hydes' collection of Johnson and his circle came to Harvard: Boswell's "Ebony Cabinet." This piece of seventeenth-century Flemish furniture had belonged to Boswell's Dutch great-grandmother and remained in the family for centuries. At different times the cabinet had contained, among other treasures, Boswell's most important papers. In May 1976, at a Christie's sale of the contents of Malahide Castle, Mary bought it for $20,000. Her bequest of the Ebony Cabinet to Yale and its placement in the Beinecke Rare Book and Manuscript Library reunited this iconic object with its former contents.[22] At the same time, the gift recognized the Hydes' long association with the University, in particular with the Beinecke's first librarian Fritz Liebert.

Among Johnson collectors in the second half of the twentieth century, Liebert was second only to the Hydes—albeit by some considerable distance.[23] Their shared interest in Johnson and the period brought Liebert and the Hydes together. In September 1946, at a dinner held at Four Oaks Farm to celebrate Johnson's birthday, they co-founded the "Johnsonians." Together, in the years that followed, they planned the annual event and produced its associated printed keepsakes. Several folders of correspondence detail the Hydes' relationship with Liebert—the friendship, rivalries, scholarly pursuits, and social activities. Despite rifts that had occurred between the Hydes and Yale's "Boswellian" professors, Chauncey B. Tinker and Frederick A. Pottle, Liebert's affability and scholarly integrity, together with a mutual regard for Yale itself, helped to overcome these difficulties. Equally, the friendship of the Hydes with Liebert's boss, Yale librarian James

21 Letter (copy), Mary Hyde Eccles to Arthur A. Houghton Jr., 14 June 1985, MS Hyde 98 (859). Mary wrote: "My decision has been made in anguish because of . . . Don's & my feeling for you & the loss of a cause cherished for twenty years. . . . I felt I had to make it—in the primary interest of the Collection. It will have more secure and scholarly future in the Morgan Library than at Harvard for this great Research library does not face the pressures that are yearly increasing at Harvard."

22 For an article on the subject see, Joseph Reed, "James Boswell's Ebony Cabinet at Yale," *Yale University Library Gazette*, October 2007.

23 The majority of Liebert's collection went to Yale after his death in December 1994. Some duplicates were sold to Gerald Goldberg and have subsequently come to Houghton Library.

T. Babb, ensured that whatever conflicts might arise, good will and good manners would prevail.

It would be interesting to know to what extent the Hydes' purchase of the Adam Collection in 1948 (against a rival attempt by Yale supported by Professor Tinker) facilitated Yale's subsequent purchase of Colonel Isham's Boswell Papers less than a year later. The papers of Donald Hyde describe the circumstances of this acquisition in detail. For Hyde it was a fully satisfying resolution as he explained to Babb on 6 July 1949: "I shall always consider any part that I may have played in it a major accomplishment of my active years. Since my first glimpse of and early contact with the Papers it has been my ambition to see them forever together for the use of scholars. They are to me one of the great discoveries of literary history scarcely equalled by anything in this country."[24]

As Johnson collectors, it was inevitable from time to time that the Hydes and Liebert (buying for himself or on behalf of Yale) would find themselves to be rivals. At an early stage, they made an informal agreement not to compete at auction over items of mutual interest and whenever possible to consult over acquisitions. Nevertheless, in May 1951 when Liebert saw an advance proof of the New York dealer Emily Driscoll's catalogue containing a Johnson letter to the novelist Samuel Richardson—a letter which presented an opportunity for him to produce a scholarly article—he seized his opportunity. This annoyed Donald Hyde, and although Liebert expressed contrition, he could hardly have expected the Hydes to accept his suggestion that, "since you are concentrating on mss. and I on books, it would be logical to agree that we should give each other first choice in each."[25]

As neither party wished to harm the friendship, Donald Hyde offered an accommodation: "You buy what you want whenever you have the opportunity, whether it be at auction or privately, and whether it be manuscripts or books, Johnson, Boswell, or otherwise. I will do the same. We will both be disappointed, no doubt, but we will also have the pleasure of knowing that the material is available if we need it." Rather optimistically, he added, "And we shall have removed all possible source of friction."[26] (The Johnson-Richardson letter in question did finally end up in the Hyde Collection.)

24 Letter (copy), Donald Hyde to James Babb, 6 July 1949, MS Hyde 98 (503).

25 Letter from Fritz Liebert to Donald Hyde, undated but before 19 May 1951, MS Hyde 98 (953).

26 Letter (copy) from Donald Hyde to Fritz Liebert, 19 May 1951, MS Hyde 98 (953). In a subsequent letter to Hyde of 23 May, Liebert continued the discussion, outlining his rationale as a scholar-collector. The Johnson-Richardson letter, dated 17 April 1753, is item 113 in Driscoll's Catalogue No. 12, priced $200. I am grateful to Fernando Peña of the Grolier Club for unearthing this information.

THE DREAMS OF A COLLECTOR

It may seem that the Donald & Mary Hyde Collection of Dr. Samuel Johnson can now only grow slowly: a Johnson or Boswell letter here, a rare printed book there. But there is one lacuna, one enormous gap, which if filled would transform the collection in an unprecedented way. More than two hundred letters written by Johnson to Boswell, as well as numerous Boswell replies—the majority published in part in the *Life of Johnson*—have not been seen since Boswell's death. Boswell certainly treasured these letters, and he referred to them on several occasions. But their whereabouts remains unknown.

Mary Hyde never abandoned the hope that this important trove would be found. One trail seemed to indicate that the letters might be in a dormant safe deposit box at a branch of Coutts Bank in London. Boswell had at one time left the letters with his bookseller, Charles Dilly, who banked with Coutts. Such were Mary's persistent thoughts on the matter that in her will the terms of the Harvard bequest stipulated that funds from the principal of the $15 million endowment could be invaded to secure the Johnson-Boswell letters were they ever to come to light. Having seen the Boswell papers emerge from cupboards and haylofts over several decades, she did not think herself unrealistic to hold out such hope. In 1950, after further unexpected discoveries of Boswell's papers at Malahide Castle, Donald Hyde told their friend and fellow collector Wilmarth Lewis: "Mary . . . still dreams of material remaining. I think she will only be convinced if the castle and all the out buildings were pulled down stone by stone! I do not take her point of view lightly as often the intuition of a woman is better than the cold judgment of a man."[27]

Perhaps such notions are, to paraphrase Johnson himself, the "doomed dreams" of a collector. Yet it would certainly be fitting that the hopes of Mary Hyde, the greatest collector of Johnson since Boswell, should be realized and that the missing correspondence between these two compelling figures might grace some future Johnson exhibition.

27 Letter (copy), Donald Hyde to Wilmarth Lewis, 7 July 1950, MS Hyde 98 (949).

The Donald & Mary Hyde Collection
of Dr. Samuel Johnson:

A Chronology

16 September 1939: Marriage of Donald Frizell Hyde (17 April 1909 – 5 February 1966), of Chillicothe, Ohio, and Mary Morley Crapo (8 July 1912 – 26 August 2003), of Detroit.

April 1940: At an exhibition in Detroit of rare books and manuscripts by Alvin C. Hammer, a New York dealer, the Hydes make their first "antiquarian" purchases, including Johnson's *Dictionary* and Boswell's *Life of Johnson*. They are advised by Randolph G. Adams of the Clements Library at the University of Michigan.

November 1940: The Hydes move to New York City and are introduced to bookmen, such as the dealer Dr. A. S. W. Rosenbach, the collector Arthur A. Houghton Jr., Colonel Ralph H. Isham of Boswell Papers fame, Morgan librarian Frederick B. Adams, and Harvard librarian William A. Jackson.

April, May, and October 1941: The A. Edward Newton sales at which the Hydes buy a number of choice items through Dr. Rosenbach, including Johnson's silver teapot for $650.

14 October 1943: Donald Hyde elected to the Grolier Club, proposed by Frederick B. Adams and seconded by William A. Jackson.

December 1945 – August 1948: The Hydes buy (for $34,000) from Colonel Isham Johnson-Boswell material which had been discovered at Malahide Castle and Fettercairn House.

18 September 1946: First meeting of the "Johnsonians" at Four Oaks Farm, the Hydes' home near Somerville, New Jersey, to celebrate Dr. Johnson's 237th birthday.

13 September 1948: Purchase of the "R. B. Adam Library Relating to Dr. Samuel Johnson and his Era" from the children of R. B. Adam II of Buffalo for $157, 500.

April 1949: The library extension at Four Oaks Farm is completed.

Autumn 1955: The Hydes' article about their library is published in the "Contemporary Collectors" series (vi) of the *Book Collector* (Vol. iv, No. 3).

September 1958: Publication of the Yale Edition of Johnson's *Diaries, Prayers, and Annals*, edited by E. L. McAdam Jr. with Donald and Mary Hyde.

22 September 1959: Opening at the Morgan Library of "Samuel Johnson, LL.D. (1709–1784), an Exhibition of First Editions, Manuscripts, Letters, and Portraits to Commemorate the 250th Anniversary of his Birth, and the 200th Anniversary of the Publication of his *Rasselas*." Curated by Herbert Cahoon, the exhibition includes nearly seventy items from the Hyde Collection.

January 1962: David Fleeman, of Pembroke College, Oxford, accepts the Hydes' offer to serve as their librarian and produce a catalogue of the Johnson printed book collection. It was published posthumously as the *Bibliography of the Works of Samuel Johnson* (2000).

16 December 1964: Donald Hyde elected to the Roxburghe Club, proposed (in 1961) by Major J. R. Abbey and A. N. L. Munby.

14 January 1966: Houghton Library "Exhibit of Books and Manuscripts from the Johnsonian Collection formed by Mr. and Mrs. Donald F. Hyde," curated by Sidney Ives.

5 February 1966: Death of Donald Hyde of cancer.

Autumn 1967: Publication of *Four Oaks Farm* and *Four Oaks Library*, edited by Gabriel Austin, with the latter containing thirteen articles written by experts on collections formed by the Hydes: Samuel Johnson, James Boswell, Hester Thrale Piozzi, Henry Fielding, Other 18th-Century Authors, 18th-Century Pictures, Miscellaneous Autographs, Japanese Books and Manuscripts, Oscar Wilde, George Bernard Shaw, Elizabethan Books and Early Drama, English and Other Bindings, and Other Collections.

January 1972: Publication by Harvard University Press of Mary Hyde's *The Impossible Friendship: Boswell and Mrs Thrale*.

9 September 1976: Mary Hyde elected to the Grolier Club, proposed by Gordon N. Ray and seconded by Herman W. Liebert. She is one of the first female members.

August 1977: Publication by Harvard University Press of Mary Hyde's *The Thrales of Streatham Park*.

17 September 1977: Opening at Houghton Library of the Donald Hyde Rooms, the $500,000 renovation paid for by Arthur A. Houghton Jr. (60 percent) and Mary Hyde (40 percent), based on the 1961 idea of Donald Hyde and William A. Jackson.

1983: Mary Hyde appointed an Honorary Curator of Eighteenth-Century Literature at Harvard College Library.

7 November 1985: Mary Hyde (Viscountess Eccles since her marriage to David Eccles on 26 September 1984) elected to the Roxburghe Club, proposed (on 26 April 1985) by the Earl of Bessborough and seconded by the Earl of Perth. She is the first female member.

1992-1994: Publication of the five-volume Hyde Edition of the *Letters of Samuel Johnson*, edited by Bruce Redford (Princeton University Press).

September 1993: Acquisition of "The Queeney Letters," 750 letters written to Hester Maria Thrale (afterwards Lady Keith), the daughter of Hester and Henry Thrale. Purchase price: £250,000.

December 1995: *Boswell's Book of Company at Auchinleck 1782-1795*, edited by the Viscountess Eccles and Gordon Turnbull, presented to the Roxburghe Club.

24 February 1999: Death of Viscount Eccles.

August 2002: Publication of *Mary Hyde Eccles: A Miscellany of Her Essays and Addresses*, edited by William Zachs (Grolier Club).

26 August 2003: Death of Mary Hyde Eccles of heart failure.

April 2004: Harvard receives a bequest of the "Donald & Mary Hyde Collection of Dr. Samuel Johnson," along with an endowment in excess of $15 million.

A Monument More Durable Than Brass:

The Donald & Mary Hyde Collection of Dr. Samuel Johnson

To raise monuments more durable than brass, and more conspicuous than pyramids, has been long the common boast of literature.

<div align="right">

The Rambler, No. 106

</div>

In April 1940, a recently married Mary Hyde gave her husband Donald first editions of Samuel Johnson's *A Dictionary of the English Language* and James Boswell's *The Life of Samuel Johnson, LL.D.* Over the next sixty years, the Hydes (and, after Donald's death in 1966, Mary herself) assembled the premier collection on the life and work of Samuel Johnson, and that of his circle of associates in eighteenth-century Great Britain. Since the collection was bequeathed to Harvard University in 2004, the staff of Houghton Library has been working to preserve, catalogue, digitize, and expand the collection. Now, on the 300th anniversary of Samuel Johnson's birth, the library is pleased to present a comprehensive exhibition of the treasures it contains for the first time in more than forty years.

Samuel Johnson is widely known for his *Dictionary* (1755), but was a writer of the first order in a dazzling variety of genres: poetry, drama, literary criticism, biography, and the essay. As recorded in Boswell's *Life* (1791), Johnson was eighteenth-century London's greatest conversationalist, and surrounded himself with many of the leading lights of his age, including Sir Joshua Reynolds, David Garrick, Oliver Goldsmith, and Edmund Burke.

The Hyde Collection contains copies of virtually all of Johnson's published works, more than half of his surviving letters, authorial manuscripts, works of art, and personal artifacts. It likewise documents the life and work of many of Johnson's friends, particularly James Boswell and Hester Thrale Piozzi, and indeed the whole of the period now known as the Age of Johnson.

In the essay from *The Rambler* quoted above, Johnson observes that libraries often serve to display the vanity of intellectual endeavor, preserving the works of authors once lauded but now relegated to obscurity. In Johnson's case, nothing could be further from the truth. Three centuries after his birth, Johnson continues to be the subject of intense scholarly examination, and the Hyde Collection is an enduring monument to his genius.

Samuel Johnson: A Chronology

1709: Samuel Johnson is born in Lichfield, England to Michael and Sarah Johnson.

1728: Johnson enrolls in Pembroke College, Oxford. Unable to continue paying his bills, he withdraws little more than a year later.

1731: "Messia," Johnson's Latin translation of Alexander Pope's "Messiah" is published in Husbands' *Miscellany*, the first of his works to see print.

1735: Johnson marries Elizabeth (Jervis) Porter, a widow twenty years his senior. With the inheritance from her late husband, he opens a grammar school. Attracting few pupils, he is forced to close it in January 1737.

1737: With his friend and former pupil David Garrick, Johnson sets off for London to pursue a career as an author.

1738: Johnson's poem *London*, his first important literary work, is published anonymously.

1746: Johnson begins work on his dictionary, and writes *A Short Scheme for Compiling a New Dictionary of the English Language*, published the following year.

1749: David Garrick's Drury Lane Theatre performs Johnson's tragedy *Irene*. Johnson publishes his poem *The Vanity of Human Wishes*.

1750: Johnson issues the first of his twice-weekly series of essays entitled *The Rambler*. It will continue for two years, totaling 208 installments, all but seven written by Johnson.

1752: Elizabeth Johnson dies. Johnson never remarries.

1755: After nine years of labor, *A Dictionary of the English Language* is published.

1759: Johnson writes *The Prince of Abyssinia* (better known as *Rasselas*), in just one week's time, to pay the expenses of his mother's final illness and funeral.

1762: Johnson is granted a royal pension of £300 per year.

1763: Johnson meets James Boswell for the first time.

1764: Sir Joshua Reynolds founds the Club, its membership drawn from Johnson's circle of friends.

1765: Johnson publishes his long-awaited edition of the works of Shakespeare.

1773: Boswell and Johnson tour Scotland together; the trip forms the basis of Johnson's *A Journey to the Western Islands of Scotland* (1775) and Boswell's *The Journal of a Tour to the Hebrides, with Samuel Johnson, LL.D.* (1785).

1779: Johnson publishes the first volumes of his *Prefaces, Biographical and Critical, to the Works of the English Poets*, completed in 1781.

1784: Johnson dies on 13 December, at age 75. He is buried in Westminster Abbey the following week.

A
CATALOGUE
OF
Choice Books in all Faculties,

Divinity, Hiſtory, Travels, Law, Phyſick, Mathematicks, Philoſophy, Poetry, &c.

Together with Bibles, Common-Prayers, Shop-Books, Pocket-Books, &c. Alſo fine French Prints for Stair-Caſes, and large Chimney Pieces, Maps large and ſmall.

To be Sold by Auction, or he who bids moſt, at the Talbot in *Sidbury Worceſter*, the Sale to begin on *Friday* the 21ſt of this Inſtant *March*, exactly at Six a-Clock in the Afternoon, and to continue till all be Sold. The Books to be expos'd to View three Days before the Sale begins.

Catalogues are given out at the Place of Sale, or by *Michael Johnſon* of *Litchfield*.

The Conditions of *SALE*.

I. THat he who bids moſt is the Buyer; but if any Difference ariſe, which the Company cannot decide, the Book or Books to be put to Sale again.

II. That all the Books, for ought we know are perfect; but if any appear otherwiſe before taken away, the Buyer to have the choice of taking or leaving them.

III. That no Perſon advance leſs than 6 d. each Bidding, after any Book comes to 10s. nor ‖‖in any Book or Set of Books, under half Value.

☞ *Note,* Any Gentleman that cannot attend may ſend his Orders, and they ſhall be faithfully executed.

Printed for *Mich. Johnſon.* 1717-18.

Michael Johnson. *A Catalogue of Choice Books in All Faculties.* [Lichfield]: M. Johnson, 1717–18. *2003J-SJ1162 (item 2.)

Case 1: Young Sam Johnson

Ah, Sir, I was rude and violent. It was bitterness which they mistook for
frolick. I was miserably poor, and I thought to fight my way by my literature
and my wit; so I disregarded all power and all authority.

The Life of Samuel Johnson, LL.D.

1. *The Holy Bible, Containing the Old Testament and the New.*
 Cambridge: J. Field, 1657. *2003J-SJ958

2. Michael Johnson. *A Catalogue of Choice Books in All Faculties.*
 [Lichfield]: M. Johnson, 1717–18. *2003J-SJ1162

3. Edward Francis Finden. *Portrait of Michael Johnson*. London:
 J. Murray, 1835. Engraving. MS Hyde 100

By all accounts, Samuel Johnson's father Michael (1657–1731) was a good bookman,
but a bad businessman. His bookshop made him prominent and popular in the
Johnsons' hometown of Lichfield, but his lack of interest in account keeping,
overambitious acquisitions, and ill-fated ventures in tanning and parchment-
making left him chronically in debt and behind on his taxes. This Bible is an
example of Michael Johnson's work as a binder, a necessary skill for a provincial
bookseller. His regular customer Sir William Boothby seems not to have been
favorably impressed, however, writing to complain: "Your books do open very ill
so that it is troublesome reading pray mend this great fault."

4. Unidentified artist. *Samuel Johnson's birthplace*. Watercolor on
 paper. MS Hyde 100

The year before Samuel's birth, Michael Johnson built the family's house himself,
placing it in the heart of Lichfield, Market Square, where it would be best
positioned to house his bookshop. The house still stands today, and has been
turned into a Johnson museum.

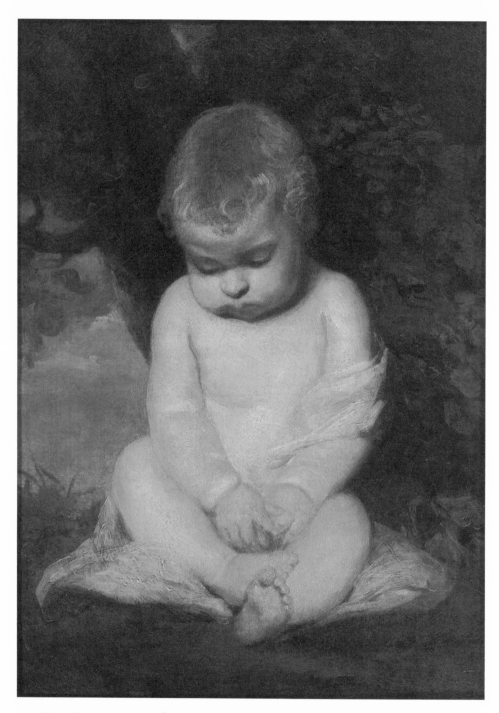

Sir Joshua Reynolds. *The Infant Johnson*. [ca. 1780]. Oil on canvas. *2003JM-4 (item 5.)

5. Sir Joshua Reynolds. THE INFANT JOHNSON. [ca. 1780]. Oil on canvas.
 *2003JM-4

 The question of whether this painting is in fact intended to depict Johnson as a
 baby remains somewhat controversial. It was first sold in 1796 simply as "Study of
 a Naked Boy," and not described as a portrait of Johnson until 1844, in a catalogue
 of the art collection of the 3rd Marquess of Lansdowne, with the rather casual aside
 that "Sir Joshua said that he intended it to represent Dr. Johnson when a year old.
 One can imagine him something like it at that age." Of course, since Reynolds
 (1723–1792) was Johnson's junior by 14 years, it would have been a portrait painted
 from his imagination as well. The painting remained in the same family for more
 than a century, until it was purchased by the Hydes from the 8th Marquess of
 Lansdowne in 1952.

6. Samuel Johnson. HORACE BOOK 2ᴰ ODE 20ᵀᴴ. 1726. Manuscript. MS
 Hyde 50 (25)

 Many of Johnson's earliest surviving compositions are translations of Horace from
 Latin into English, written while Johnson was at Stourbridge Grammar School
 under the tutelage of the Rev. John Wentworth (d. 1741). He later told Boswell that
 "Horace's Odes were the compositions in which he took most delight."

7. John Husbands. A MISCELLANY OF POEMS, BY SEVERAL HANDS.
 Oxford: L. Lichfield, 1731. *2003J-SJ3

8. George Hollis, after Joseph Nash. PEMBROKE COLLEGE, OXFORD.
 Oxford: J. Ryman, 1838. Engraving. MS Hyde 100

 This collection of poems, primarily written by John Husbands (1706–1732), is most
 notable for containing the first appearance in print of a work by Samuel Johnson.
 "Messia," a Latin translation of Alexander Pope's "Messiah," was written in 1728
 as a Christmas vacation assignment for his tutor at Pembroke College, Oxford,
 William Jorden (1685–1739), who then passed it on to his Pembroke colleague,
 Husbands. Although Johnson was just nineteen when he wrote it, he remained
 sufficiently pleased with "Messia" to republish it with minor revisions in the
 Gentleman's Magazine in 1752.

8 Horace Book 2d Ode 20th

Now with no weak unballast wing
A Poet double-form'd I rise
From th' invious world with scorn I spring,
And cut with joy the wondring Skies.

Though from no Princes I descend,
Yet shall I see the blest abodes,
Yet, great Mæcenas shall your friend
Quaff Nectar with th' immortal Gods.

See! how the mighty Change is wrought!
See! how whate'er remain'd of Man
By plumes is veil'd; see! quick as thought
I pierce the Clouds a tunefull Swan.

Swifter than Icarus I'll flie
Where Lybia's swarthy offspring burns,
And where beneath th' inclement Skies

Samuel Johnson. Horace Book 2d Ode 20th. 1726. Manuscript. MS Hyde 50 (25) (item 6.)

9. Samuel Johnson. LETTER TO GREGORY HICKMAN. October 30, 1731. Manuscript. MS Hyde 1 (48)

In this, his earliest surviving letter, Johnson writes to his cousin Gregory Hickman (1688–1748), who had unsuccessfully tried to secure Johnson a schoolmaster's position a few months earlier. At the time, Johnson was (unhappily) living at home, and his father Michael's health was rapidly failing. "As I am yet unemploy'd, I hope You will, if anything should offer, remember and recommend, Sir, Your humble servant."

10. Samuel Johnson. ANNALES. 1734. Manuscript. MS Hyde 50 (6)

11. Samuel Johnson. LIBELLUS. 1729–1734. Manuscript. MS Hyde 50 (31)

Johnson kept diaries throughout his life, and these are the earliest to have survived. Annales is a simple accounting, in Latin, of the major events in his life, beginning with his birth in 1709 and ending with the publication of his now lost prospectus for an edition of the poems of Politian. The Libellus, or little book, contains occasional entries from 1729 through 1734, beginning with Johnson's determination, as translated by Boswell, that "I bid farewell to Sloth, being resolved henceforth not to listen to her syren strains." This is followed by a plan of Latin authors to begin reading, and a table of how much he could accomplish if he read 10, 50, or even 600 lines a day.

12. Samuel Johnson. LETTER TO EDWARD CAVE. November 25, 1734. Manuscript. MS Hyde 1 (17)

Still seeking a way to establish himself in a career, Johnson writes to the publisher of the *Gentleman's Magazine*, Edward Cave (1691–1754), under the pretext of representing someone unnamed wishing to write for the magazine, presumably because his own name carries no weight:

> As You appear no less sensible than Your Readers of the defects
> of your Poetical Article, you will not be displeased, if, in order to
> the improvement of it, I communicate to You the sentiments of a
> person, who will undertake on reasonable terms sometimes to fill a
> column.

Cave apparently did not reply to this curious missive, but by 1738 Johnson would become a regular contributor and worked for Cave for several years.

ANNALES

Nov.ris 10mo 1734

A.D. 1709 Sept.ris 7mo

Samuel Johnson Lichfieldiæ natus est.

1725 Mensibus Autumnal.

S.J. ad se vocavit C.F. a quo, anno proxime insequenti, Pentecostes ferijs, Lichfieldiam redijt.

1728

Novris 1mo

S.J. Oxonium se contulit.

Samuel Johnson. Annales. 1734. Manuscript. MS Hyde 50 (6) (item 10.)

Oct: 1729

[manuscript Latin text, partly illegible]

Oct. 22 ...

Die	Hebdom:	Mense	Anno Nov21
10	60	240	2880.
30	180	720	8640.
50	300	1200	14400.
60	360	1440	17280.
150	900	3600	Nᵇ singulis heb domadis 6 Dies singulis mensibus 4 Hebdomadæ singulis annis 12 menses nume rantur
300	1800	7200	
400	2400	9600	
600	3600	14400	

Samuel Johnson. Libellus. 1729–1734. Manuscript. MS Hyde 50 (31) (item 11.)

Sir Answerd Decr Novr 25th 1734

As you appear no less sensible than your Readers of the defects of your Poetical Article, You will not be displeased, if, in order to the improvement of it, I communicate to you the Sentiments of a person, who will undertake on reasonable terms sometimes to fill a column.

His opinion is, that the Publick would not give you a bad reception, if, beside the current Wit of the Month, which a critical examination would generally reduce to a narrow Compass, You admitted not only Poems, Inscriptions &c never printed before, which he will sometimes supply You with; but likewise short Literary Dissertations in Latin or English, Critical Remarks on Authours Ancient or Modern, forgotten Poems that deserve Revival, or loose pieces, like Floyer's, worth preserving. By this Method your Literary Article, for so it might be call'd, will, he thinks, be better recommended to the Publick, than by low Jests, awkward Buffoonery, or the dull Scurrilities of either Party.

If such a Correspondence will be agreable to you, be pleased to inform me in two posts, what the Conditions are on which You shall expect it. Your late offer gives me no reason to distrust your Generosity. If you engage in any Literary projects besides this Paper, I have other designs to impart if I could be secure from having others reap the advantage of what I should hint.

Your letter, by being directed to S. Smith to be left at the Castle, in Birmingham, Warwickshire, will reach Your humble Servant.

Samuel Johnson. Letter to Edward Cave. November 25, 1734. Manuscript.
MS Hyde 1 (17) (item 12.)

13. Jerónimo Lobo. *A Voyage to Abyssinia*. London: A. Bettesworth and C. Hitch, 1735. *2003J-SJ5

In 1733, Johnson was unemployed and living in Birmingham with his friend Edmund Hector (1708–1794), who rented a room from the printer Thomas Warren (d. 1767). For the sum of five guineas, Warren hired Johnson to make an English translation of a French translation of a travel narrative by the Portuguese missionary Jerónimo Lobo (1596?-1678). This, Johnson's first substantial published work, was the first of many occasions in which Johnson contracted his services to a publisher, and set a pattern of procrastination which he repeated throughout his literary career. Boswell writes:

> [H]is constitutional indolence soon prevailed, and the work was at a stand. Mr. Hector, who knew that a motive of humanity would be the most prevailing argument with his friend, went to Johnson, and represented to him, that the printer could have no other employment till this undertaking was finished, and that the poor man and his family were suffering. Johnson upon this exerted the powers of his mind, though his body was relaxed. He lay in bed with the book, which was a quarto, before him, and dictated while Hector wrote.

14. *The Gentleman's Magazine* for June 1736. London: E. Cave, 1736. *2003J-SJ950

Shortly after his marriage to Elizabeth Porter (1689–1752), Johnson settled in the town of Edial, just outside of Lichfield, his birthplace. Having unsuccessfully tried to work as a teacher in other schools, and not yet receiving any substantial income from his literary efforts, Johnson established his own school, for which he attempted to solicit students by placing an advertisement in the June 1736 issue of the *Gentleman's Magazine*: "At Edial, near Litchfield in Staffordshire, Young Gentlemen are Boarded, and Taught the Latin and Greek Languages, by Samuel Johnson." The advertisement failed to provide the hoped-for boost to enrollment, and Johnson was forced to close the school just eight months later. However, Johnson's time as a schoolmaster did have one lasting impact on his life: one of his students, David Garrick (1717–1779), who later attained prominence on the London stage, became Johnson's lifelong friend.

15. Unidentified artist. *SAMUEL JOHNSON*. [ca. 1736]. Oil on metal.
 *2003JM-213

Little is known about this work, the earliest portrait of Johnson. It belonged to
his wife Elizabeth, and was probably painted shortly after their marriage in 1735.
Johnson is said to have later given it to Elizabeth Barber, the wife of his longtime
servant, Frank. The Johnsonian Herman Liebert said of it:

> Although it is not of artistic merit, it has considerable evidentiary
> value. The characteristic tilt of the head to the right, the blandness
> of the sightless left eye, the heavy, rather sensual features . . . seen
> in the later portraits, of which, in its artlessness, it is convincing
> confirmation.

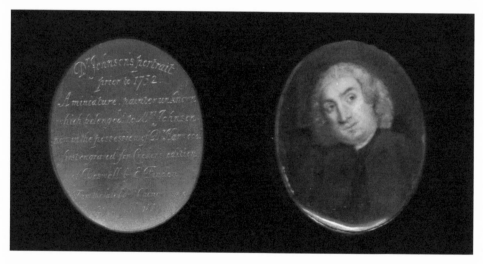

Unidentified artist. *Samuel Johnson*. [ca. 1736]. Oil on metal. *2003JM-213 (item 15.)

Case 2: Johnson in London

When a man is tired of London, he is tired of life; for there is in London all that life can afford.

The Life of Samuel Johnson, LL.D.

16. Gilbert Walmsley. Letter to John Colson. March 2, 1737. Manuscript. MS Hyde 10 (732)

Johnson and his friend and former pupil David Garrick traveled from Lichfield to London in 1737, with Johnson hoping to get his yet-unfinished play *Irene* produced for the stage. With only one horse between them, they took turns riding and walking during a 120-mile journey that took several days. They carried with them this letter of introduction from one of Johnson's most important mentors, Gilbert Walmsley (1680–1751). Walmsley wrote to Colson (1680–1760), who had agreed to take Garrick on at his school in Rochester, that "Johnson is a very good scholar & poet, & I have great hopes will turn out a fine tragedy writer."

17. Samuel Johnson. London. 1738. Manuscript. MS Hyde 50 (33)

18. Samuel Johnson. *London, a Poem in Imitation of the Third Satire of Juvenal*. London: R. Doddesley [*sic*], 1738. *2003J-SJ9

Even though published anonymously, *London* announced Johnson's arrival on the literary scene with a grand flourish, and attracted the favorable notice of no less a figure than Alexander Pope (1688–1744). When informed that the author was an obscure man named Johnson, Pope correctly predicted "He will soon be *déterré* [unearthed]." The poem is unsparingly bleak in its depiction of the city, and reflects Johnson's struggle to survive on literary piecework in his early years there.

This mournful Truth is ev'ry where confest,
Slow rises Worth, by Poverty deprest.

Lichfield,
Mar. 2. 173$\frac{6}{7}$.

Dear Sir,

 I had the Favour of Yours & am extreamly oblig'd to you: Butt cannot say, I have a greater Affection for You upon it than I had before, being long since so much Endear'd to You, as well by an early Friendship, as by your many excellent & valuable Qualifications. And had I a son of my own, it wou'd be my Ambition, instead of sending to a University, to dispose of him as this Young Gentleman is. He & another Neighbour of mine, one Mr. Johnson, set out this morning for London together: Davy Garrick to be wth You early ye next week, & Mr. Johnson to try his Fate wth a Tragedy, & to see to get himself employ'd in some Translation either from ye Latin or ye French. Johnson is a very good Scholar & Poet, & I have great hopes will turn out a fine Tragedy-Writer. If it shou'd any ways ly in

Gilbert Walmsley. Letter to John Colson. March 2, 1737. Manuscript. MS Hyde 10 (732) (item 16.)

Samuel Johnson. London. 1738. Manuscript. MS Hyde 50 (33) (item 17.)

19. Richard Savage. Sir Thomas Overbury: A Tragedy. 1723. Manuscript. MS Hyde 31

The playwright and poet Richard Savage (d. 1743) spent much of his short life pressing his claim, probably untrue, to be the illegitimate son of the Earl Rivers and the Countess of Macclesfield. The more squalid details of his life, including his conviction for murder, for which he later received a royal pardon, have overshadowed his literary accomplishments. For a brief time in the late 1730s, he and Johnson were close friends, and Johnson would later write that the two of them roamed the streets of London at night, deep in conversation, when they had no place to sleep. After Savage's death in debtors' prison in 1743, Johnson wrote a biography that acknowledged Savage's many faults but also movingly defended him:

> Those are no proper Judges of his Conduct, who have slumber'd away their Time on the Down of Affluence, nor will any wise man presume to say, "Had I been in Savage's condition, I should have lived, or written, better than Savage."

20. Thomas Osborne. *Proposals for Printing, by Subscription, the Two First Volumes of Bibliotheca Harleiana.* [London: T. Osborne], 1742. *2003J-SJ42

21. Thomas Osborne. *Catalogus bibliothecæ Harleianæ.* [London: T. Osborne], 1743–45. *2003J-SJ45

Early in his literary career, Johnson earned most of his income by work for hire for booksellers and publishers. One such example is his association with Thomas Osborne (d. 1767), who in 1741 spent £13,000 to acquire the great library of Robert Harley, Earl of Oxford (1661–1724). To recoup this very sizable investment, Osborne hired Johnson and William Oldys (1696–1761) to produce a sale catalogue for the collection with enough scholarly annotation to be useful as a reference work. Osborne solicited subscriptions to fund the project and this prospectus was circulated as an advertisement. This copy was apparently unsuccessful in that goal as the receipt at the bottom of the title page was never filled out and returned. This is one of a handful of surviving copies of the prospectus. This copy of the *Catalogus* was a gift from the Grolier Club to Donald Hyde in recognition of his service as President from 1961 to 1965.

November, 1, 1742.

PROPOSALS

For Printing, by

SUBSCRIPTION,

The Two FIRST VOLUMES of

BIBLIOTHECA HARLEIANA:

OR, A

CATALOGUE

OF THE

LIBRARY

OF THE

Late EARL of OXFORD,

PURCHASED BY

THOMAS OSBORNE, BOOKSELLER, in *Gray's-Inn.*

CONDITIONS.

Each Volume will contain Thirty Sheets, at least, in *Octavo,* on a fine Paper, and new Letter.

The Price, to SUBSCRIBERS, will be Ten Shillings ; Half to be paid at the Time of Subscribing, and the rest on the Delivery of the Two Volumes.

The Two Volumes will be delivered some Time in *February* next.

That the Learned of Foreign Nations, and those that reside in the Country, may have timely Notice of the Sale, it will be deferred to the Second of *May.* The Books will be exposed to View from *Wednesday* the Sixth, to *Wednesday* the Twentieth of *April,* from Nine in the Morning, to Four in the Afternoon.

N. B. *It is intended, that the whole Catalogue shall not exceed four Volumes in Octavo.*

REceived of the Sum of
being the first Payment for the two first Volumes of the Bibliotheca Harleiana,

Thomas Osborne. *Proposals for Printing, by Subscription, the Two First Volumes of Bibliotheca Harleiana.* [London: T. Osborne], 1742. *2003J-SJ42 (item 20.)

Let Observation with extensive view
Survey Mankind from China to Peru
Explore each ~~restless~~ anxious toil each eager strife
And all the busy Scenes of crowded life
Then say how ~~~~ Hope desire and raging Hate
O'erspread with snares the clouded maze of Fate
Where wav'ring Man betray'd by vent'rous pride
To tread the dang'rous paths without a Guide
As treach'rous Phantoms in the mist delude
Shuns fancied Ills or chases airy Good
How rarely Reason guides the stubborn choice
Rules the bold hand or prompts the Suppliant
How Nations Sink ~~~~ by darling Schemes oppress'd
When Vengeance listens to the Fool's Request
Fate wings with ev'ry wish th' afflictive dart
Each Gift of Nature and ~~each~~ ~~~~ Art
With fatal Heat impetuous Courage glows
With fatal Sweetness Elocution flows
Impeachment stops the Speaker's pow'rful breath
20 And restless Enterprize impells to death.

Samuel Johnson. The Vanity of Human Wishes. 1748. Manuscript. MS Hyde 50 (63) (item 22.)

22. Samuel Johnson. THE VANITY OF HUMAN WISHES. 1748. Manuscript. MS Hyde 50 (63)

23. Samuel Johnson. RECEIPT TO ROBERT DODSLEY FOR *THE VANITY OF HUMAN WISHES*. 1748. Manuscript. MS Hyde 50 (52)

24. Samuel Johnson. *THE VANITY OF HUMAN WISHES*. London: R. Dodsley, 1749. *2003J-SJ89

The Vanity of Human Wishes is regarded as Johnson's greatest poem. It is also the first of his works to bear his name on the title page, a clear sign of Johnson's increasing status in the literary world. As the receipt records, Johnson sold the poem to publisher Robert Dodsley (1703–1764) for fifteen guineas, a 50 percent increase over his payment for *London*. Like *London*, *The Vanity of Human Wishes* is an imitation of a satire by the Roman poet Juvenal and contrasts the emptiness of seeking after fame or riches with the fulfillment of religious faith.

25. Samuel Johnson. ACT V OF IRENE. 1746. Manuscript. MS Hyde 50 (2)

26. Samuel Johnson. *IRENE: A TRAGEDY*. London: R. Dodsley, 1749. *2003J-SJ92

Johnson's brightest prospect of income, when setting off for London in 1737, was to get his tragedy *Irene* produced, but it would take more than a decade for that to occur. *Irene* is based on an episode related in Richard Knolles' 1603 *The Generall Historie of the Turkes*, and tells the story of the Turkish Sultan Mahomet (Mehmed II, 1432–1481) falling in love with a Greek woman, Irene, at the siege of Constantinople. Although the play was substantially completed by 1741, Johnson continued to revise it, as this manuscript shows. David Garrick, having taken over the management of the Drury Lane Theatre, was able in 1749 to give his friend's play a fairly successful nine-night run, providing Johnson with nearly £200 in much-needed income.

Samuel Johnson. A Short Scheme for Compiling a New Dictionary of the English Language. 1746. Manuscript. MS Hyde 50 (38) (item 27.)

Case 3: Dictionary Johnson

*Lexicographer: A writer of dictionaries; a harmless drudge that busies himself
in tracing the original, and detailing the signification of words.*

A Dictionary of the English Language

27. Samuel Johnson. A Short Scheme for Compiling a New
 Dictionary of the English Language. 1746. Manuscript. MS Hyde
 50 (38)

28. Samuel Johnson. The Plan of a Dictionary of the English
 Language. Transcript in a scribal hand, with authorial corrections, 1746
 or 1747. Manuscript. MS Hyde 50 (39)

29. Samuel Johnson. *The Plan of a Dictionary of the English
 Language*. London: J. and P. Knapton, 1747. *2003J-SJ81

 In 1746, a consortium of London publishers led by Robert Dodsley, recognizing a
 sizable market for a comprehensive dictionary of English, approached Johnson to
 undertake such a project. They knew it would be a lengthy and expensive endeavor,
 although they as yet had no idea just how lengthy and expensive it would be. They
 first asked Johnson to draw up a preliminary outline of the project. After Johnson
 made revisions to the first draft, a second draft was shown to Philip Stanhope, Earl
 of Chesterfield (1694–1773), who offered a handful of suggested revisions as well.
 Widely regarded as an authority on linguistic matters, Chesterfield's endorsement
 was seen as key to the marketability of the dictionary, and indeed both the second
 draft and the published version are addressed to him directly.

30. Virgil. *The Æneid . . . Translated by Mr. Pitt*. London:
 R. Dodsley, 1740. *2003J-SJ984

Samuel Johnson. The Plan of a Dictionary of the English Language. Transcript in a scribal hand, with authorial corrections. 1746 or 1747. Manuscript. MS Hyde 50 (39) (item 28.)

296 VIRGIL's ÆNEID. BOOK VII.

SOON as her Funeral Rites the Prince had paid,
And rais'd a Tomb in Honour of the Dead;
(The Sea subsiding, and the Tempests o'er,)
He spreads the flying Sails, and leaves the Shore. 10
When, at the Close of Night, soft Breezes rise,
The Moon in milder Glory mounts the Skies:
Safe in her friendly Light the Navy glides;
The Silver Splendors trembling o'er the Tides.
Now by rich *Circe*'s Coast they bend their Way, 15
(*Circe*, fair Daughter of the God of Day;)
A dangerous Shore: the echoing Forests rung,
While at the Loom the beauteous Goddess sung.
Bright Cedar Brands supply her Father's Rays,
Perfume the Dome, and round the Palace blaze. 20
Here Wolves with Howlings scare the Naval Train,
And Lions roar, reluctant to the Chain.
Here growling Bears and Swine their Ears affright,
And break the Solemn Silence of the Night.
These once were Men; but *Circe*'s Charms confine, 25
In Brutal Shapes, the human Forms Divine.
But NEPTUNE, to secure the pious Host
From these dire Monsters, this Inchanted Coast,

A Friendly

Virgil. *The Æneid . . . Translated by Mr. Pitt*. London: R. Dodsley, 1740. *2003J-SJ984 (item 30.)

Alexander Macbean. Quotations from Shakespeare transcribed for the *Dictionary*. [ca. 1755]. Manuscript. MS Hyde 50 (72) (item 31.)

31. Alexander Macbean. Quotations from Shakespeare transcribed for the *Dictionary*. [ca. 1755]. Manuscript. MS Hyde 50 (72)

One of the many intellectual achievements of the *Dictionary* is the dazzling array of quotations from literature used to illustrate the meaning and proper use of words, a reflection of Johnson's voracious appetite for reading. Johnson annotated this edition of Virgil in preparation for the 1773 revised edition of the *Dictionary*, marking passages to be quoted in the text and giving the first letter of the key word in the margin. These would later be compiled by his amanuenses, or assistants, for integration into the manuscript. This manuscript fragment contains quotations from *King John* and *Richard II*, transcribed by Alexander Macbean (d. 1784) for the 1755 first edition. Johnson ultimately decided to use Dryden's translation of Virgil as his source instead of this one, but the quotations from Shakespeare ended up in the definitions of "almsman" and "figure."

32. Samuel Johnson. Fragment of "The Grammar of the English Language." [ca. 1755]. Manuscript. MS Hyde 50 (64)

Almost nothing survives of the manuscript of the *Dictionary*, but this single leaf from the introduction is one of the most substantial fragments extant. It is also an especially significant one, given that it concerns a subject so important to Johnson: versification, "the arrangement of a certain number of syllables according to certain laws."

33. Samuel Johnson. *A Dictionary of the English Language*. London: J. and P. Knapton, 1755. The Earl of Chesterfield's copy. *2003J-SJ182

34. Samuel Johnson. Letter to the Earl of Chesterfield. February 7, 1755. Transcript in another hand. MS Hyde 10 (372)

35. Samuel Johnson. *The Celebrated Letter from Samuel Johnson, LL.D. to Philip Dormer Stanhope, Earl of Chesterfield*. London: C. Dilly, 1790. *2003J-SJ1160

Chesterfield's patronage of the *Dictionary* never materialized, and indeed he seemed to take little notice of the project during the ordeal of its compilation. However, shortly before its publication in 1755, Chesterfield wrote two articles for the fashionable magazine *The World*, praising Johnson and his *Dictionary*. This created

Samuel Johnson. Fragment of "The Grammar of the English Language." [ca. 1755]. Manuscript. MS Hyde 50 (64) (item 32.)

THE CELEBRATED

LETTER

FROM

SAMUEL JOHNSON, LL.D.

TO

PHILIP DORMER STANHOPE, EARL OF CHESTERFIELD;

NOW FIRST PUBLISHED,

WITH NOTES,

BY JAMES BOSWELL, ESQ.

LONDON:

PRINTED BY HENRY BALDWIN;

FOR CHARLES DILLY, IN THE POULTRY.

MDCCXC.

[Price Half a Guinea.]

Samuel Johnson. *The Celebrated Letter from Samuel Johnson, LL.D. to Philip Dormer Stanhope, Earl of Chesterfield.* London: C. Dilly, 1790. *2003J-SJ1160 (item 35.)

the intolerable impression that Chesterfield had been carefully shepherding the project forward all along. This impression was further fostered by the republication of the 1747 *Plan of a Dictionary*, with its dedication to Chesterfield. Johnson forcefully asserted his place as the true father of the *Dictionary* in a scathing letter in which he repudiated Chesterfield in particular and patronage in general. "Is not a Patron, My Lord, one who looks with unconcern on a Man struggling for Life in the water and when he has reached ground encumbers him with help?" Although the original letter itself no longer survives, several copies dictated by Johnson do, as he was not shy about sharing its contents with those in his circle (since, of course, the function of the letter was to correct a public misimpression). James Boswell's copy of the letter would end up in his biography of Johnson, but was initially printed in this rare stand-alone publication, presumably issued to secure his copyright in the sensational text.

36. *The Smallest English Dictionary in the World*. New York: F. Stokes, [ca. 1893]. *2003J-SJ249

The first edition of the *Dictionary* was a large and very expensive book; its £4 10s. price would be the equivalent of more than $750 today. The following year, the publishers released a smaller abridged edition for just ten shillings, and by the 1790s, even smaller pocket-sized editions were appearing, albeit with little relationship to Johnson's original text. This process of reduction reached an extreme in this microscopic dictionary. Just over an inch high, it comes in its own tin carrying case with an embedded magnifying glass.

37. Samuel Johnson. *A Dictionary of the English Language*. Third edition. London: A. Millar, 1765. Fragment with manuscript annotations. MS Hyde 51 (13)

Even the greatest of works may sometimes come to an inglorious end. Boswell's note on this scrap of the *Dictionary* records that "Matthew Henderson found this in a Littlehouse [i.e., a privy] at Edinburgh & twitted me with my Great Friend's Work being Wastepaper."

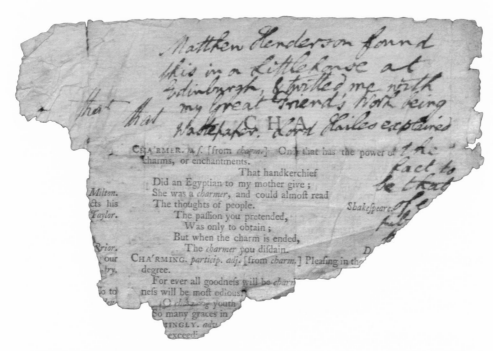

Samuel Johnson. *A Dictionary of the English Language*. Third edition. London: A. Millar, 1765. Fragment with manuscript annotations. MS Hyde 51 (13) (item 37.)

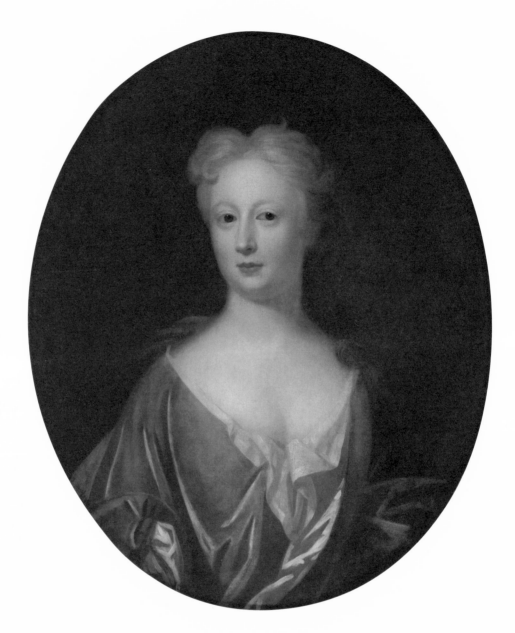

Unidentified artist. *Elizabeth Johnson*. [ca. 1735]. Oil on canvas. *2003JM-8
(item 38.)

Case 4: JOHNSON'S HOUSEHOLD

If your house be like an inn, nobody cares for you. A man who stays a week with another, makes him a slave for a week.

The Life of Samuel Johnson, LL.D.

38. Unidentified artist. *ELIZABETH JOHNSON*. [ca. 1735]. Oil on canvas. *2003JM-8

39. Samuel Johnson. LETTER TO ELIZABETH JOHNSON. January 31, 1740. Manuscript. MS Hyde 1 (57)

40. *THE RAMBLER*. London: J. Payne and J. Bouquet, 1752. Elizabeth Johnson's copy. *2003J-SJ109

During Johnson's 1732–33 residence in Birmingham, he befriended Harry and Elizabeth Porter, and often visited their home. He had since returned to Lichfield, but went to Birmingham on learning that Harry had fallen ill in the summer of 1734, and spent many hours at his bedside before Harry died at the age of 43. Less than a year later, Johnson would marry Porter's widow. It was a match that provoked widespread murmuring, as well as open opposition from Elizabeth's children and Johnson's mother Sarah. "Tetty" was twenty years Johnson's senior, and brought the considerable fortune of £600 to the marriage, while Johnson was penniless and without prospects. For his part, though, Johnson insisted that the marriage was "a love match on both sides." Johnson's only surviving letter to Tetty dates from a time in which they lived apart, their relationship strained. Johnson, having nearly exhausted Tetty's money in his failed attempt to start a school, was in Lichfield to arrange a mortgage on his mother's house, from which he received £20. Having heard that Tetty had fallen and injured her leg, Johnson writes back wracked with guilt: "I shall be very uneasy till I know that You are recovered, and beg that You will omit nothing that can contribute to it. . . . You have already suffered more than I can bear to reflect upon, and I hope more than either of us shall suffer again." Elizabeth Johnson died on 25 March 1752, a few days after inscribing this copy of the just-published *Rambler*. The copy later passed into the hands of Elizabeth Barber, the wife of Johnson's servant Frank.

Samuel Johnson. Letter to Elizabeth Johnson. January 31, 1740. Manuscript.
MS Hyde 1 (57) (item 39.)

+ March 28 1753

I kept this day as the anniversary of my
Tetty's death with prayer & tears in the morning.
In the evening I prayed for her conditionally if
it were lawful.

Apr. 3 1753. I began the 2d vol of my
Dictionary room being left in the first for
Preface Grammar & History none of them yet
begun.

O God who hast hitherto supported me
enable me to proceed in this labour & in the
Whole task of my present state that when I
shall render up at ye last day an account
of the talent committed to me I may receive
pardon for the sake of Jesus Christ Amen.

April 22 1753

As I purpose to try on Monday to seek a new
wife without any derogation from dear Tetty's
memory I purpose at sacrament in the morning
to take my leave of Tetty in a solemn commen-
: dation of her soul to God.

Apr 23 Easter Monday.

Yesterday as I purposed I went to Bromley
where dear Tetty lies buried & received the sacrament
first praying before I went to the altar accor-
ding to the prayer precomposed for Tetty

James Boswell. Transcript of Samuel Johnson's Diary for March 28–April 23, 1753.
Manuscript. MS Hyde 50 (69) (item 41.)

41. James Boswell. TRANSCRIPT OF SAMUEL JOHNSON'S DIARY FOR
 MARCH 28–APRIL 23, 1753. Manuscript. MS Hyde 50 (69)

The original diary for this period no longer exists; Johnson burned it just days
before his death. It survives through this transcript made by Boswell, and reveals
that little more than a year after Elizabeth Johnson's death, Johnson was resolved
"to try on Monday to seek a new wife without any derogation from dear Tetty's
memory. I purpose at sacrament in the morning to take my leave of Tetty in a
solemn commendation of her soul to God." It is impossible to say who, if anyone,
Johnson had in mind at this moment, but he did not in fact remarry. Boswell
opted to omit this passage from the *Life*, perhaps feeling that it reflected poorly on
Johnson's relationship with Tetty.

42. Samuel Johnson. LETTER TO FRANK BARBER. September 25, 1770.
 Manuscript. MS Hyde 1 (5)

The man known as Frank Barber (d. 1801) was born a slave in Jamaica, brought
to England as a child, and baptized under that name by his master, Richard
Bathurst. He was given his freedom in Bathurst's will, and became a servant in
Johnson's household shortly after Tetty's death. With a few exceptions, he would
remain with Johnson until the latter's death. This letter dates from the period in
which Johnson sent Barber to be educated at Bishop's Stortford Grammar School.
Johnson admonishes Barber, "Do not imagine that I shall forget or forsake you,
for if when I examine you, I find that you have not lost your time, you shall want
no encouragement." Barber later married an English wife, with whom he had five
children. He was the primary beneficiary of Johnson's estate, receiving an annuity
of £70.

43. Anna Williams. *MISCELLANIES IN PROSE AND VERSE*. London:
 T. Davies, 1766. Thomas Percy's copy. *2003J-SJ441

44. Samuel Johnson. *LONDON*. Fifth edition. London: R. Dodsley, 1750.
 Author's presentation copy. *2003J-SJ14

Along with Frank Barber, Johnson's companion of longest standing was his
blind housekeeper Anna Williams (1706–1783). As a consequence of Johnson's
acquaintance with her father Zachariah, Williams came to the Johnson household
as a companion to Tetty shortly before her death in 1752. She would remain
there for the rest of her life, with the exception of a six-year period in which she
took her own lodgings, during which time she received Johnson for a cup of tea

every evening. Johnson made numerous efforts to better her circumstances, such as arranging for her to have cataract surgery, sadly unsuccessful, from a leading London surgeon, Samuel Sharp. In 1766, Johnson arranged for the publication of a collection of her writings that raised £100 for her. As Thomas Percy (1729–1811) points out in a note in his copy, a few of the pieces were by Johnson himself. Williams' prickly personality seems to have won her few friends, but Johnson was devoted to her, writing after her death, "Her curiosity was universal, her knowledge was very extensive, and she sustained forty years of misery with steady fortitude. Thirty years and more she had been my companion, and her death has left me very desolate."

45. Unidentified artist. No. 17 Gough Square. Watercolor. MS Hyde 76 (1.5.328.1)

46. John Thomas Smith. *No. 8 Bolt Court*. Engraving. MS Hyde 100

47. John Thomas Smith. Interior of No. 8 Bolt Court. Ink on paper. MS Hyde 100

Although Johnson had several residences throughout his years in London, he is most closely associated with the house at 17 Gough Square, where he lived from 1748–1759. The house suffered years of neglect before being established as a Johnson museum, only to narrowly escape destruction in the London Blitz during World War II. Johnson's final London home was in Bolt Court, where he lived from 1776 until his death in 1784. Although the building no longer stands, it was immortalized in these works by John Thomas Smith (1766–1833), an author and artist who served as Keeper of Prints and Drawings at the British Museum.

48. John Parker and Edward Wakelin. Silver Teapot. [ca. 1765]. *2003JM-63

49. Samuel Johnson. Deed for Silver Teapot. December 6, 1784. Manuscript. MS Hyde 50 (17)

50. A Johnsonian Teaparty at "Oak Knoll," December 11, 1932. Photograph. *2003JM-63

Johnson's devotion to the drinking of tea makes this teapot one of the most evocative of his household possessions. As shown by the accompanying manuscript deed, dated one week before Johnson's death, the teapot was bequeathed to Frank

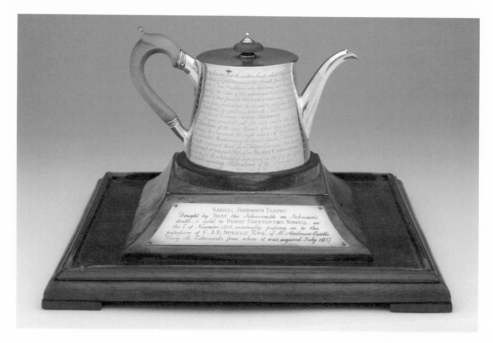

John Parker and Edward Wakelin. Silver Teapot. [ca. 1765]. *2003JM-63 (item 48.)

Barber. Instead, Johnson's executor, Sir John Hawkins (1719–1789), appears to have sold it, even as Johnson's body was being autopsied. According to the inscription on the teapot,

> It was weighed out for sale, under the Inspection of Sr. Jno.
> Hawkins, at the very Minute when they were in the next Room
> closing the incision through which Mr. Cruikshank had explored
> the ruinated Machinery of its dead Master's Thorax – so Bray (the
> Silversmith conveyed there in Sr. John's Carriage thus hastily! to
> buy the Plate) informed its present Possessor Henry Constantine
> Nowell by whom it was for its celebrated Services, on the 1st of
> Novr. 1788 rescued from the undiscriminating Obliterations of the
> Furnace.

The teapot was purchased in 1927 by the great collector A. Edward Newton, who offered a few favored guests a Johnsonian communion of sorts by serving tea from it at his home, known as Oak Knoll.

Case 5: Boswell's *Life*

Sir, you have but two topicks, yourself and me. I am sick of both.

The Life of Samuel Johnson, LL.D.

51. James Boswell. LETTER TO SAMUEL JOHNSON. March 3, 1772. Manuscript. MS Hyde 2 (20)

This letter discusses the planned trip to Scotland that would be recounted in both Johnson's *A Journey to the Western Islands of Scotland* and Boswell's *The Journal of a Tour to the Hebrides, with Samuel Johnson, LL.D.* Boswell reiterates a common theme in his correspondence with Johnson: his disappointment that Johnson does not write him more frequently.

> It is hard that I cannot prevail with you to write to me oftener.
> But I am convinced that it is in vain to push you for a private
> correspondence with any regularity. I must therefore look upon you
> as a Fountain of Wisdom, from whence few rills are communicated
> to a distance, and which must be approached at it's [*sic*] source, to
> partake fully of it's [*sic*] virtues.

52. James Boswell. *THE JOURNAL OF A TOUR TO THE HEBRIDES, WITH SAMUEL JOHNSON, LL.D.* London: C. Dilly, 1785. *2003J-JB52

The great literary scholar Edmond Malone (1741–1812) was Boswell's close friend and crucial collaborator, working closely with him on this work as well as Boswell's biography of Johnson. This copy contains Malone's annotations and corrections for a second edition of the *Journal*, which was released in 1786. A small advertisement at the back which notes "Preparing for the press, in one volume quarto, *The Life of Samuel Johnson, LL.D.*" was somewhat inaccurate: the *Life* would not be published until 1791, by which time it had grown to two hefty volumes.

My Dear Sir. Edinburgh
 3 March 1772.

 It is hard that I cannot prevail
with you to write to me oftener. But I am
convinced that it is in vain to push you
for a private correspondence with any
regularity. I must therefore look upon
you as a Fountain of Wisdom from
whence few rills are communicated
to a distance, and which must be
approached at its source, to partake
fully of its virtues.
 I fairly own that after an absence
from you for any length of time, I
feel that I require a renewal of
that spirit which your presence
always gives me, and which makes
me a better and a happier man
 than

James Boswell. Letter to Samuel Johnson. March 3, 1772. Manuscript. MS Hyde 2 (20)
(item 51.)

53. James Boswell. NOTES ON THE LIFE OF JOHNSON. 1776–1777.
Manuscript. MS Hyde 51 (19)

Boswell did not meet Johnson until 1763, so it was his tireless research into Johnson's early life and his relentless questioning of Johnson himself that made the *Life* possible. Here Boswell records an anecdote about Johnson's supposed earliest poetic composition, lines on accidentally stepping on a duckling at the age of three. Johnson insisted that the poem was actually his father's composition, an outgrowth of Michael Johnson's unwelcome enthusiasm for displaying his son's precocious intellect.

> Under this stone lyes Mr. Duck
> Whom Samuel Johnson trode on
> He might have liv'd if he had luck;
> But then he'd been an odd one.

54. James Heath, after Sir Joshua Reynolds. SAMUEL JOHNSON, 1ST AND
2ND STATES. 1791. Engravings. MS Hyde 51 (25)

Boswell commissioned James Heath (1757–1834) to engrave the frontispiece portrait of Johnson for the *Life*, after a Reynolds painting begun in 1756 but at that time still unfinished. He brought Heath's first attempt for Reynolds to critique, and Sir Joshua pronounced the likeness "too young and not thoughtful enough." Heath produced a second version incorporating Reynolds' suggestions, and this, with very slight changes, found its way into the published book, as documented here by Boswell's notes.

55. James Boswell. CANCEL LEAF FROM *THE LIFE OF SAMUEL JOHNSON,
LL.D.* London: C. Dilly, 1791. MS Hyde 51 (23)

At the last minute, Boswell ordered the printer to remove and replace a leaf from the *Life* in order to delete Johnson's very frank views on marital infidelity. Boswell has struck through the offending passage, which reads:

> [Wives] detest a mistress, but they don't mind a whore. My wife
> told me I might lye with as many women as I pleased, provided I
> *loved* her alone. BOSWELL. "She was not in earnest." JOHNSON. But
> she was; consider, Sir, how gross it is in a wife to complain of her

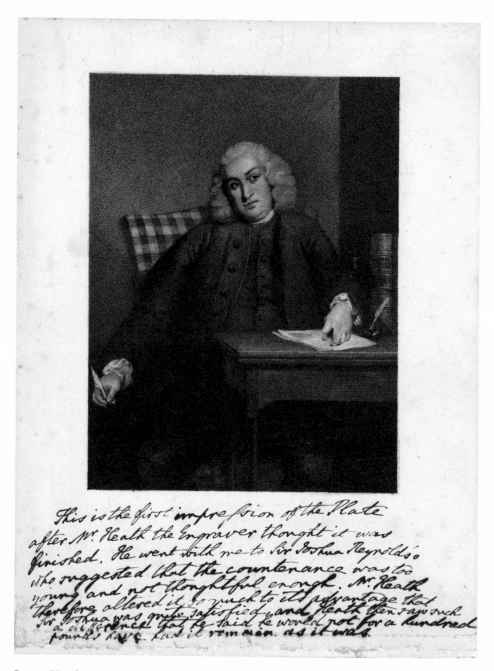

James Heath, after Sir Joshua Reynolds. Samuel Johnson, 1st state. 1791. Engraving.
MS Hyde 51 (25) (item 54.)

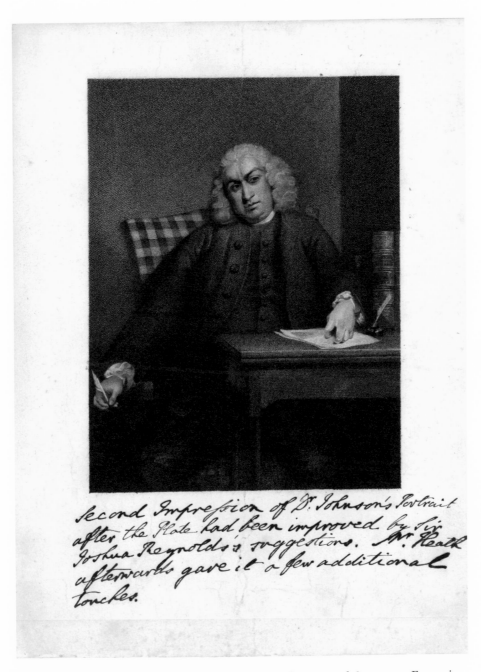

James Heath, after Sir Joshua Reynolds. Samuel Johnson, 2nd state. 1791. Engraving.
MS Hyde 51 (25) (item 54.)

husband's going to other women, merely as women; it is that she has not enough of what she would be ashamed to avow." Boswell. "And was Mrs. Johnson then so liberal, Sir?"

Shortly before publication, Boswell wrote to Edmond Malone about the cancellation, saying "I wonder how you and I admitted this to the publick eye. . . . It is however mighty good stuff."

56. James Boswell. *The Life of Samuel Johnson, LL.D*. London: C. Dilly, 1791. John Wilkes' copy. *2003J-JBL3

John Wilkes' copy of the *Life* records a somewhat more explicit version of an anecdote reported by Boswell. In the published version, Johnson tells David Garrick, "I'll come no more behind your scenes, David; for the silk stockings and white bosoms of your actresses excite my amorous propensities." Wilkes has added a footnote reading "make my genitals to quiver was Johnson's phrase, as Garrick told Mr. W." In fact, Boswell recorded the incident in much this form in the manuscript of the *Life*, but chose to soften it in the published version.

57. James Boswell. *The Life of Samuel Johnson, LL.D*. London: J. Murray, 1831. *2003J-JBL40

The Tory politician John Wilson Croker (1780–1857) was the first to attempt a comprehensive new edition of Boswell's *Life*, and to this end he accumulated masses of unpublished archival materials, added scores of explanatory footnotes, and augmented Boswell's text with extracts from a myriad of other biographies of Johnson. The resulting publication was a noble but overambitious failure. It was memorably if perhaps excessively savaged in a review by Croker's bitter political opponent, the historian Thomas Macaulay, who called it "ill compiled, ill arranged, ill written, and ill printed." The publisher Murray brought in a new editor for the second edition of 1835, and stripped Croker's name from the title page, but in 1848 Croker produced a third edition based on this heavily annotated copy of the first. Although Croker's work as an editor has been supplanted by modern, more rigorous editions of the *Life*, this working copy provides a fascinating insight into his methods.

58. Ernest H. Shepard (1879–1976). TITLE PAGE ILLUSTRATION FOR *EVERYBODY'S BOSWELL*. 1930. Ink on board. MS Hyde 95 (1)

Although Ernest Shepard is unquestionably best known for his illustrations for A. A. Milne's Winnie the Pooh books, he had a long and varied career as an illustrator and cartoonist. In 1930, G. Bell & Sons commissioned him to illustrate an abridged edition of Boswell's *Life*, and produced a suite of thirteen drawings, including the title page, which depicts Boswell and Johnson walking together down a busy London street.

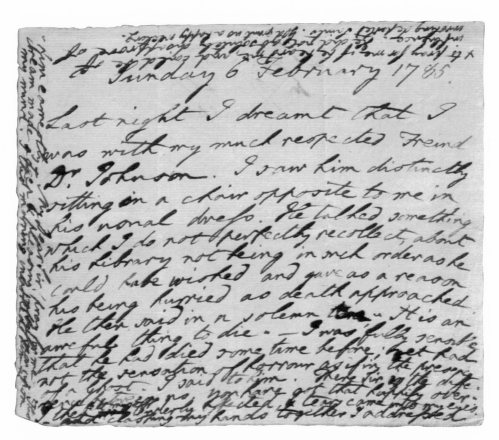

James Boswell. Diary, February 6, 1785. Manuscript. MS Hyde 51 (10) (item 60.)

59. James Boswell. Book of Company at Auchinleck Since the
Succession of James Boswell, Esq. in 1782. Manuscript. MS
Hyde 51 (3)

Boswell, laird of Auchinleck from 1782 until his death in 1795, kept detailed records
of his guests at dinner and overnight, and the sometimes staggering amounts
of wine and spirits they consumed together. The page shown here has columns
for bottles of claret, port, Lisbon, Madeira, sherry, mountain, gin, brandy, and
rum. Yet he also recorded much more personal events, such as the death from
tuberculosis of his wife Margaret in May 1789, while Boswell was away in London:

> My Wife was now exceedingly ill of that fatal disease the
> Consumption but I flattered myself that she would grow better as
> Summer advanced as she had done for the three former years. . . .
> I was in great agitation & very averse to go. But she generously
> pressed me to be resolute. Alas! the event proved fatal. I never saw
> her again alive.

60. James Boswell. Diary, February 6, 1785. Manuscript. MS Hyde 51
(10)

Less than two months after Johnson's death, Boswell recorded a dream about him
in his diary:

> Last night I dreamt that I was with my much respected Freind [*sic*]
> Dr. Johnson. I saw him distinctly sitting in a chair opposite to me
> in his usual dress. . . . He then said in a solemn tone "It is an awful
> thing to die" – I was fully sensible that he had died some time
> before; yet had not the sensation of horrour as if in the presence of
> a Ghost. . . . This dream made a deep & pleasing impression upon
> my mind. I this morning invoked him to pray for me if he heard
> me, and could be of influence. . . . God grant us a happy meeting.

Case 6: JOHNSON AND HIS BOOKS

The gradations of a hero's life are from battle to battle, and of an author's from book to book.

<div align="right">

The Idler, No. 102

</div>

61. James Christie. *A CATALOGUE OF THE VALUABLE LIBRARY OF BOOKS, OF THE LATE LEARNED SAMUEL JOHNSON, ESQ. LL.D. DECEASED.* [London: s.n., 1785]. *2003J-SJ1173b

The sale of Johnson's library packed the auction house of James Christie (founder of the firm which today bears his name) in February 1785, three months after his death. This copy of the catalogue belonged to Johnson's friend, the noted translator of Italian literature, John Hoole (1727–1803). We know from the annotations in another copy held at Houghton Library that Hoole bought several lots at the sale, including Johnson's copy of Giuseppe Baretti's Italian-English dictionary.

62. Samuel Johnson. RULES FOR THE SHELVES. Manuscript. MS Hyde 50 (57)

The backbone of any library is its bookshelves, and Johnson wrote out these rules to ensure that his were constructed correctly, with the largest, deepest shelves at the bottom, tapering down toward the top. The top shelf would have stood just under six feet high, about as tall as Johnson himself.

63. Samuel Johnson. READING RECOMMENDATIONS FOR DANIEL ASTLE. Manuscript. [ca. 1780]. MS Hyde 50 (11)

64. Samuel Johnson. REGISTER OF BOOK LOANS. Manuscript. MS Hyde 50 (32)

Johnson's associates naturally turned to him, as one of the most learned men of his age, for advice about reading, or if they were especially close, to borrow a book. Johnson provided such advice to Daniel Astle (ca. 1745–1821), lately returned from his army service in America (which included seeing action at the battle of Bunker

J. Hoole.

A
CATALOGUE

OF THE VALUABLE

Library of Books,

Of the late learned

SAMUEL JOHNSON,

Efq; LL. D.

DECEASED;

Which will be Sold by Auction,

(By ORDER of the EXECUTORS)

By Mr. CHRISTIE,

At his Great Room in Pall Mall,

On WEDNESDAY, FEBRUARY 16, 1785,

AND THREE FOLLOWING DAYS.

To be Viewed on Monday and Tuefday preceding the
Sale, which will begin each Day at 12 o'Clock.

Catalogues may be had as above.

James Chriſtie. *A Catalogue of the Valuable Library of Books, of the Late Learned Samuel
Johnson, Esq. LL.D. Deceased.* [London: s.n., 1785]. *2003J-SJ1173b (item 61.)

Samuel Johnson. Reading Recommendations for Daniel Astle. Manuscript. [ca. 1780].
MS Hyde 50 (11) (item 63.)

Hill), and beginning his studies for the ministry. The titles Johnson recommends are primarily religious and historical, but also include Walton's *The Compleat Angler*. The list shows clear signs of wear and folding, and may have been carried by Astle for some time. Boswell describes Johnson's treatment of books as "slovenly and careless" and Johnson's friends learned to be wary of lending their books to him. He was occasionally willing to lend his own books out, however, as this scrap of paper records loans to Giuseppe Barretti and Elizabeth Desmoulins, among others.

65. Bible, Greek. *Tēs theias graphēs, palaias dēladē kai neas diathēkēs, apanta = Divinae Scripturae, nempe Veteris ac Novi Testamenti, omnia*. Francofurti: C. Marnius & J. Aubrius, 1597. *2003J-SJ986

As discussed earlier, Johnson was hired by the bookseller Thomas Osborne to catalogue the great library of Robert Harley, the Earl of Oxford. Perhaps because of the tension between Johnson's scholarly interest in the project and Osborne's commercial one, their relationship was not entirely smooth. One day, when Johnson lingered too long over a particular item, Osborne berated him for sloth with a tirade of profanity. Johnson responded by knocking Osborne down with a large, heavy book. Johnson later told Boswell simply, "Sir, he was impertinent to me, and I beat him." Although it is a difficult claim to verify conclusively, this Bible may be the very instrument of Osborne's punishment. Certainly it does come from Robert Harley's library, and with its thick wooden boards, it would make a formidable weapon. An inscription inside, signed J. Miles, states, "This is the identical book with which Dr. Johnson knock'd down Osborne the bookseller & bought by me at Harleian sale."

66. Robert Burton. *The Anatomy of Melancholy*. Sixth edition. Oxford: H. Cripps, 1651. *2003J-SJ993a

Johnson told Boswell that *The Anatomy of Melancholy* "was the only book that ever took him out of bed two hours sooner than he wished to rise." If so, then this was the copy that greeted him some of the many mornings he spent at Streatham Park, the country home of his friends Henry (1728–1781) and Hester Thrale (1741–1821). Johnson grappled with depression throughout his life, and found that reading the *Anatomy* provided solace from "distressing thoughts" in his darker moments.

67. Petronius Arbiter. *Satyricon*. Amsterdam: J. Blaeu, 1669. *2003J-SJ959

This volume has the earliest dated inscription of any of Johnson's books in the Hyde Collection. In 1727, Johnson was an eighteen-year-old ostensibly working in his father's bookshop, but he was far more interested in reading its contents than waiting on customers.

68. John Milton. *Paradise Regain'd*. London: J. Tonson, 1725. *2003J-SJ965

Although Johnson regarded Milton as among the greatest of English writers, he was also the subject of one of Johnson's most famous critical barbs.

> *Paradise Lost* is one of the books which the reader admires and lays down, and forgets to take up again. None ever wished it longer than it is. Its perusal is a duty rather than a pleasure. We read Milton for instruction, retire harassed and overburdened, and look elsewhere for recreation; we desert our master, and seek for companions.

Even so, Johnson's final verdict on the poem was praise of the highest sort: "[It] is not the greatest of heroick poems, only because it is not the first."

69. Velleius Paterculus. *Historiæ Romanæ*. Leiden: S. Luchtmans, 1719. *2003J-SJ957

Two great authors owned this copy of Paterculus' history of Rome. It was sold as lot 257 in the auction of Johnson's library; the sale price of seven shillings is marked at the top of the front endpaper. Some time thereafter, it came into the possession of William Wordsworth (1770–1850), who later gave it to his nephew Christopher, at his home in the Lake District, Rydal Mount. Johnson resolved to study Paterculus in his 1729 Libellus entry, and in a 1735 letter to his younger cousin Samuel Ford, recommended him as an author of one of the "purest ages" of Latin literature.

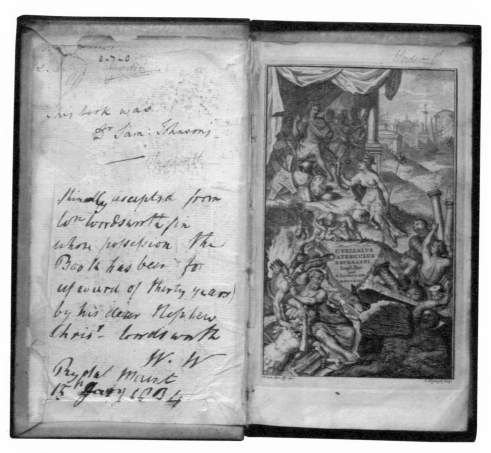

Velleius Paterculus. *Historiæ Romanæ*. Leiden: S. Luchtmans, 1719. *2003J-SJ957 (item 69.)

70. Samuel Johnson. REVIEW OF *THE SUGAR-CANE* BY JAMES GRAINGER. 1764. Manuscript. MS Hyde 50 (55)

The Sugar-Cane is the most significant work of the physician and minor poet James Grainger (1721?-1766), and perhaps owes some of its modest fame to an incident Boswell retold in the *Life*. "This poem, when read in manuscript at Sir Joshua Reynolds', had made all the assembled wits burst into a laugh, when, after much blank-verse pomp, the poet began a new paragraph thus: 'Now, Muse, let's sing of rats.'" Apparently Grainger was sufficiently chastened to cut this line, as it does not appear in the published work.

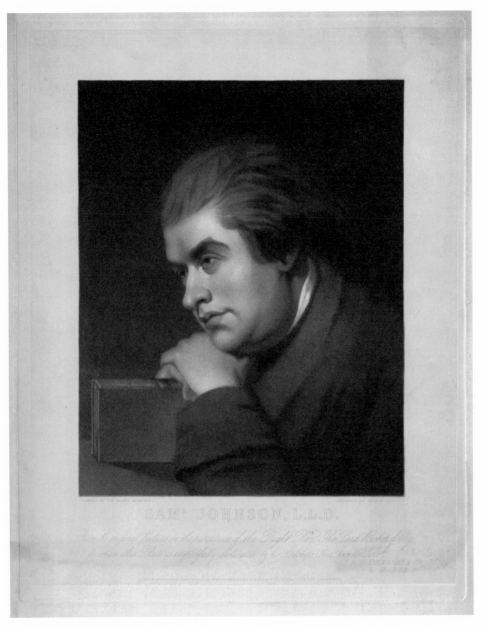

George Zobel. *Samuel Johnson*. London: P. & D. Colnaghi, [1854]. Mezzotint. MS Hyde 100 (item 71.)

71. George Zobel. *Samuel Johnson*. London: P. & D. Colnaghi, [1854].
 Mezzotint. MS Hyde 100

A young, highly romanticized Johnson is depicted resting on a copy of his play
Irene. The original painting upon which Zobel's mezzotint is based, now in the
Johnson birthplace museum in Lichfield, is no longer attributed to Reynolds as it
was in the nineteenth century.

72. Gilbert Stuart. *Samuel Johnson*. [1783?]. Oil on canvas. *2003JM-15

Gilbert Stuart (1755–1828), the American portraitist best known for the image of
George Washington on the one-dollar bill, spent more than a decade in London,
during which time he was introduced to Johnson. Johnson condescendingly
complimented the young man from the Colonies on how well he spoke English,
and asked where he had learned it. A bristling Stuart replied, "Sir, I can better tell
you where I did not learn it—it was not from your dictionary." Johnson realized he
had overstepped his bounds and did not take offense at the remark. A nineteenth-
century inscription on this portrait suggests that it was painted from life, during
Johnson's 1783 visit to the home of William Bowles, but it is, if not a direct copy,
certainly an imitation of Sir Joshua Reynolds' 1775 portrait commonly known as
"Blinking Sam."

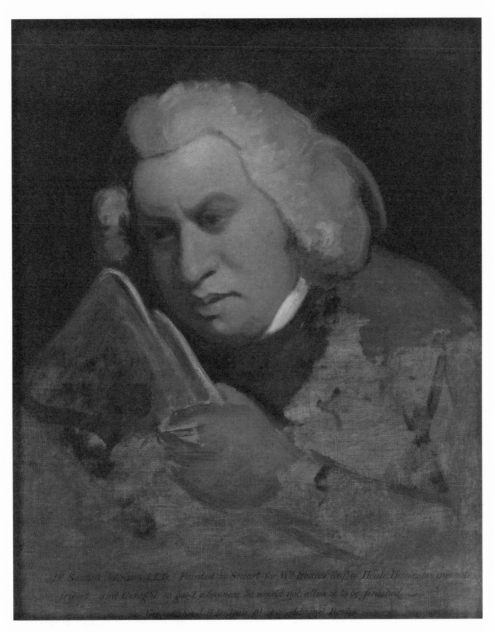

Gilbert Stuart. *Samuel Johnson*. [1783?]. Oil on canvas. *2003JM-15 (item 72.)

When the Club was first instituted I was not resident in London, it being at first limited to eight members, no vacancy offering for more till about 1768; When in consequence of S.ᵗ John's (then M.ʳ) Hawkins's having withdrawn from the Club, it was agreed by the remaining members to extend their number to Twelve: and then M.ʳ Chambers (now S.ʳ Robert) ——— M.ʳ Colman & myself were elected. — I was rec.ᵈ therein on Monday Evening, 15.ᵗʰ Feb. 1768, for at that time & for several years, the Club always met to sup & spend the Evening every Monday during the winter & Spring months. And with the above addition, the Club then consisted of the following Members.

1. Dʳ Sam. Johnson.
2. Mʳ (afterwᵈˢ) Sʳ Joshua Reynolds
3. Mʳ Burke
4. Dʳ Nugent (Mʳ Burke's wife's father
5. Mʳ Dyer * (Samuel)
6. Dʳ Goldsmith
7. Mʳ Chamier (a Gentleman of Fortune, sometime Under-Secretary of War.)
8. Mʳ Langton
9. Mʳ Beauclerc (who had forsaken the Club, but afterwards returned to it)
10. Mʳ (now Sʳ Robt) Chambers, then Vinerian Professor of Law at Oxford
11. Mʳ Colman
12. Myself, (Revᵈ Mʳ Percy.)

* Mʳ Dyer was a great friend of the Burkes: and if you wish to have it, I will try to recover the Eloge wᶜʰ Edmund Burke printed in the newspapers on Dyer's death.

Thomas Percy. Account of the Founding of the Club. 1788. Manuscript. MS Hyde 24 (item 73.)

Case 7: Johnson and His Circle

Sir, I look upon every day to be lost, in which I do not make a new acquaintance.

The Life of Samuel Johnson, LL.D.

73. Thomas Percy. ACCOUNT OF THE FOUNDING OF THE CLUB. 1788. Manuscript. MS Hyde 24

Boswell relentlessly canvassed Johnson's friends and associates for reminiscences to incorporate into the *Life*. One of his principal informants was Thomas Percy, Bishop of Dromore (Ireland) and author of *Reliques of Ancient English Poetry*. Percy was one of the earlier members of the Club, also known as the Literary Club, which Sir Joshua Reynolds founded in 1764. He drafted an account of its founding, as well as a list of its members, for Boswell's use. Percy recounts that the Club was for many years limited to just twelve members including, at the outset, Johnson, Oliver Goldsmith, and Edmund Burke. They intended

> that the Club should consist of such men as that if only **two** of them chanced to meet, they should be able to entertain each other sufficiently without wishing for more company with whom to pass an evening.

74. D. George Thompson, after James William Edmund Doyle. *A LITERARY PARTY AT SIR JOSHUA REYNOLDS'S*. [ca. 1850]. Engraving. *2003JM-199

Doyle's painting probably captures a general sense of Johnson's circle around the time of the Club's founding, rather than a particular evening. Depicted, from left to right, are Boswell, Johnson, Reynolds, David Garrick, Edmund Burke, Pasquale Paoli, Charles Burney, Thomas Warton, and Oliver Goldsmith. The black man bringing drinks to the table may be Johnson's servant, Frank Barber.

75. Samuel Johnson. LETTER TO HESTER THRALE PIOZZI. July 2, 1784. Manuscript. MS Hyde 1 (93)

Samuel Johnson. Letter to Hester Thrale Piozzi. July 2, 1784. Manuscript.
MS Hyde 1 (93) (item 75.)

Mrs Thrale to Dr Johnson 4 July 1784.

Sir —

I have this Morning received from You so rough a
Letter, in reply to one which was both tenderly &
respectfully written, that I am forced to desire
the conclusion of a Correspondence which I can
bear to continue no longer. the Birth of my
second Husband is not meaner than that of my
first, *his sentiments are not meaner* his Profession is not meaner, — and his
Superiority in what heprofesses — acknowledged
by all Mankind. — It is want of Fortune then
that is <u>ignominious</u>, the Character of the Man
I have chosen has no other Claim to such an
Epithet. The Religion to which he has
been always a zealous Adherent will I hope
teach him to forgive Insults he has not
deserved — mine will I hope enable me to
bear them at once with Dignity & Patience.
To hear that I have forfeited my Fame is in:
:deed the greatest Insult I ever yet received,
my Fame is unsullied as Snow or I should
 think it unworthy

Hester Thrale Piozzi. Letter to Samuel Johnson. July 4, 1784. Manuscript.
MS Hyde 3 (57) (item 76.)

76. Hester Thrale Piozzi. Letter to Samuel Johnson. July 4, 1784.
 Manuscript. MS Hyde 3 (57)

It is difficult now precisely to characterize the relationship between Johnson and
Hester Thrale, but there can be no doubt that it was intense and intimate. For
nearly twenty years, Johnson was a frequent houseguest and the center of a literary
salon at the Thrales' country house at Streatham Park. After Henry Thrale's death
in 1781, the gossips whispered that she and Johnson might marry. Instead, Hester
shocked both Johnson and her family by marrying Gabriel Piozzi (1740–1809), her
daughters' music teacher. Johnson wrote her an anguished letter upon learning of
her decision, thundering "If I interpret your letter right, you are ignominiously
married, if it is yet undone, let us once talk together. If you have abandoned your
children and your religion, God forgive your wickedness; if you have forfeited
your fame and your country, may your folly do you no further mischief." And yet,
written sideways in the margin, there is an attempt at reconciliation: "I will come
down if you permit it." She was not to be dissuaded, however, and wrote back
immediately, "I have this morning received from you so rough a letter, in reply to
one which was both tenderly and respectfully written, that I am forced to desire
the conclusion of a correspondence which I can bear to continue no longer." The
rift remained unhealed at Johnson's death six months later.

77. Samuel Johnson. Ode to Mrs. Thrale. 1773. Manuscript. MS Hyde
 50 (36)

78. James Boswell. *Ode by Dr. Samuel Johnson to Mrs. Thrale, Upon
 Their Supposed Approaching Nuptials.* London: R. Faulder, 1784
 [i.e. 1788] *2003J-JB74

These might at first seem to be the manuscript and published versions of the same
work, but in fact these odes have different authors and sharply different intentions
behind them. The first is indeed by Johnson, written on the Isle of Skye during
his Hebridean tour. Although the tone is adoring, he clearly considered the poem
sufficiently platonic to forward it to Hester Thrale in a letter addressed to her
husband Henry. A stanza, in a nineteenth-century English translation of the Latin
original, reads:

> Through paths that halt from stone to stone,
> Amid the din of tongues unknown,
> One image haunts my soul alone,
> Thine, gentle Thrale!

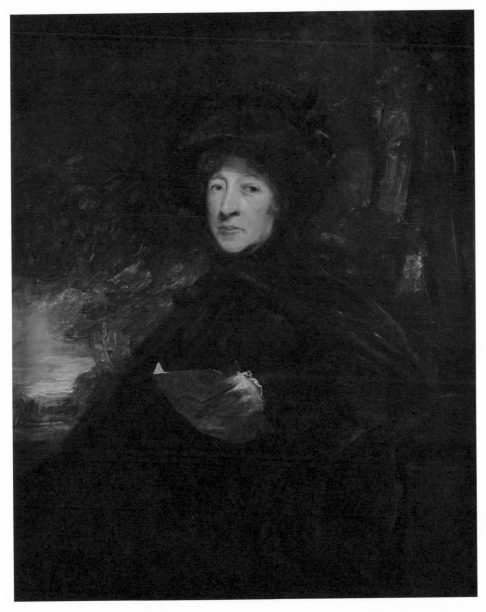

John Jackson. *Hester Thrale Piozzi*. 1810. Oil on wood. *2003JM-5 (item 79.)

The second poem is the work of Boswell, written just days after Henry Thrale's death, and is a biting satire on the notion of Johnson succeeding him as Hester's husband. (Boswell biographer Frank Brady called it a "combination of unusual wit and extraordinary tastelessness.") Boswell circulated the poem privately, but in 1788 published it in retribution for perceived slights against him in Hester Thrale's *Anecdotes of the Late Samuel Johnson*. In an allusion to Henry Thrale's brewery, Boswell writes:

> My dearest lady! view your slave,
> Behold him as your very Scrub,
> Eager to write as authour grave,
> Or govern well the brewing tub.

79. John Jackson. *Hester Thrale Piozzi*. 1810. Oil on wood. *2003JM-5

80. James Boswell. *The Life of Samuel Johnson, LL.D*. London: Cadell & Davies, 1807. Annotated by Hester Thrale Piozzi. *2003J-TP61

"I have a Trick of writing in the Margins of my Books. It is not a good Trick, but one longs to say something" Hester Thrale Piozzi wrote in her diary. Indeed, the Hyde Collection holds dozens of books from her library, many extensively annotated. This is one of the most significant. She and Boswell were rivals for Johnson's attention during his life and for his legacy after his death, but Mrs. Piozzi kept up her end of the rivalry for many years after Boswell's death in 1795. Throughout this copy, and in another, also held at Houghton Library, Mrs. Piozzi challenges Boswell on his recollection of events, particularly when, as here, she is portrayed in an unflattering light. The story of Johnson's rebuke to her cannot be true, she maintains, since she never ate larks, nor dared to address the Great Cham (Tobias Smollett's enduring nickname) as "My dear Johnson."

81. Oliver Goldsmith. *The Deserted Village, a Poem*. London: W. Griffin, 1770 [i.e., 1777] *2003J-SJ426a

Johnson's friendship with Oliver Goldsmith (1730?-1774) was also at times a literary collaboration. Most notably, Johnson rescued Goldsmith from debtors' prison by selling the manuscript of *The Vicar of Wakefield* to a publisher for £60. Johnson had a small but more active hand in the composition of Goldsmith's poem *The Deserted Village*, and at Boswell's request, marked out the last four lines as his own work.

James Boswell. *The Life of Samuel Johnson, LL.D.* London: Cadell & Davies, 1807.
Annotated by Hester Thrale Piozzi. *2003J-TP61 (item 80.)

82. Sir Joshua Reynolds. Reminiscence of Oliver Goldsmith. [ca.
1774]. Manuscript. MS Hyde 9 (11)

One of the luminaries of Johnson's circle remembers another in this fragment of
an essay on Goldsmith by his close friend Reynolds. It may have been written at
the request of Thomas Percy for his biography of Goldsmith. A fuller version was
found in the Boswell papers now at Yale.

> The regret his friends felt for his loss was perhaps
> greater than any they had ever before experienced. . . .
> Those familys in which he lived in intimacy wish'd him
> always present and thought every meeting defective or
> insipid if the Doctor was not among them.

Thomas Rowlandson. *The Hanging of Dr. Dodd.* [ca. 1777]. Ink and watercolor on paper.
*2003JM-28 (item 84.)

83. Samuel Johnson. DEDICATION TO JOHN HOOLE'S *JERUSALEM DELIVERED*. 1763. Manuscript. MS Hyde 50 (15)

Despite his famous distaste for patronage, Johnson excelled at writing dedications to the wealthy, the powerful, and the royal, and performed this service for his friends on numerous occasions. Johnson composed this dedication to Queen Charlotte (1744–1818), wife of George III, to precede his friend John Hoole's translation of the epic Italian poem by Torquato Tasso, *La Gerusalemme liberata*.

84. Thomas Rowlandson. *THE HANGING OF DR. DODD*. [ca. 1777]. Ink and watercolor on paper. *2003JM-28

Clergyman and author William Dodd's extravagant tastes and fashionable dress earned him both the unflattering nickname "The Macaroni Parson" and a lifetime spent in debt. Pressed by creditors, he made the disastrous decision in 1777 to forge a £4,200 letter of credit from the Earl of Chesterfield, whose son he had tutored for several years. The fraud was quickly discovered, and despite prompt restitution and a jury recommendation for mercy, Dodd was sentenced to death. Johnson became closely involved with a campaign to spare Dodd's life, writing several speeches published under Dodd's name, including *The Convict's Address to His Unhappy Brethren*. The effort was unsuccessful, however, and Dodd was executed in June 1777. Rowlandson's drawing captures the crush of spectators gathered to witness the hanging, while Lord Chesterfield watches from the comfort of his carriage.

85. Sir Joshua Reynolds. *DAVID GARRICK*. [ca. 1775]. Oil on canvas. *2003JM-7

This portrait of Garrick has a remarkable provenance. It formed part of a set of portraits known as the Streatham Worthies, the circle of literary and artistic greats who often gathered at the Streatham Park home of Henry and Hester Thrale. The collection eventually grew to encompass thirteen paintings, all by Reynolds, and included portraits of Johnson, Oliver Goldsmith, Edmund Burke, and a Reynolds self-portrait. In 1816, the contents of Streatham Park were sold, and Dr. Charles Burney, son of Johnson's friend of the same name, bought the portrait of Garrick. It would remain in the Burney family for more than a century. The portrait of Streatham's owner, Henry Thrale, also resides in the Hyde Collection.

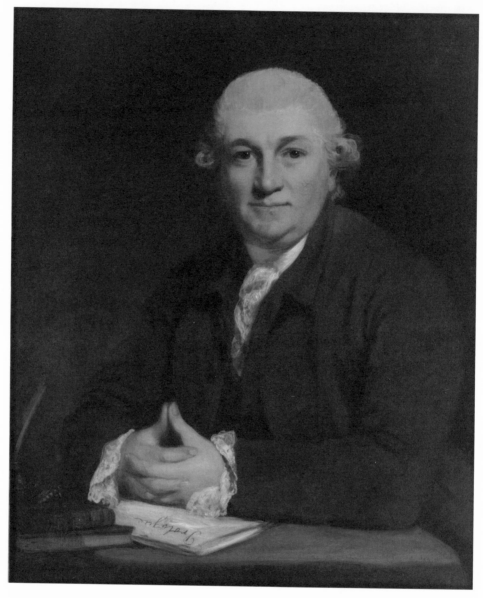

Sir Joshua Reynolds. *David Garrick*. [ca. 1775]. Oil on canvas. *2003JM-7 (item 85.)

Case 8: LATER JOHNSON

He that in the latter part of his life too strictly inquires what he has done,
can very seldom receive from his own heart such an account as will give him
satisfaction.

<div align="right">

The Idler, No. 88

</div>

86. Samuel Johnson. LETTER TO JAMES MACPHERSON. January 20, 1775.
Manuscript. MS Hyde 1 (74)

James Macpherson (1736–1796) was an unknown, twenty-three-year-old Edinburgh
schoolteacher when the publication of *Fragments of Ancient Poetry Collected in the*
Highlands of Scotland made him an instant literary celebrity. Macpherson claimed
that the poems were the work of a third-century Gaelic bard named Ossian, and
later published two full-length epic poems he said he had discovered from ancient
manuscripts. Macpherson's refusal to produce these manuscripts for inspection, as
well as Johnson's mistaken belief that there were no surviving Gaelic manuscripts
more than a century old, led to Johnson denouncing the poems as forgeries in
A Journey to the Western Islands of Scotland. Macpherson wrote to Johnson's publisher
demanding that this passage be stricken. Johnson refused to back down:

> I received your foolish and impudent note. Whatever insult is
> offered me I will do my best to repel, and what I cannot do for
> myself, the law will do for me. I will not desist from detecting what
> I think a cheat, from any fear of the menaces of a Ruffian.

Johnson was right to be skeptical: although Macpherson had drawn upon some
genuine sources, the bulk of his "Ossianic" poetry was his own fabrication.

87. Samuel Johnson. *PROPOSALS FOR PRINTING A NEW EDITION OF THE*
PLAYS OF WILLIAM SHAKESPEAR. London: E. Cave, 1745. *2003J-SJ62

88. Samuel Johnson. *PROPOSALS FOR PRINTING, BY SUBSCRIPTION, THE*
DRAMATICK WORKS OF WILLIAM SHAKESPEARE. London: J. and R.
Tonson, 1756. *2003J-SJ261b

Samuel Johnson. Letter to James Macpherson. January 20, 1775. Manuscript.
MS Hyde 1 (74) (item 86.)

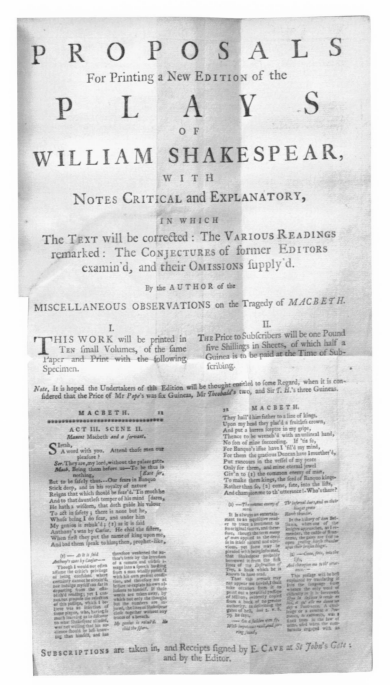

Samuel Johnson. *Proposals for Printing a New Edition of the Plays of William Shakespear.*
London: E. Cave, 1745. *2003J-SJ62 (item 87.)

89. William Shakespeare. *The Plays . . . to Which Are Added, Notes by Sam. Johnson*. London: J. and R. Tonson, 1765. *2003J-SJ720

No project of Johnson's was longer in its gestation than his edition of Shakespeare's plays. In 1744, Johnson was a struggling young writer, subsisting largely on the work he submitted to the *Gentleman's Magazine* publisher Edward Cave. He proposed that Cave publish an inexpensive edition of Shakespeare in ten volumes, for which he would provide extensive annotations and commentary. Johnson immersed himself in the project for months, and then published this prospectus, attached to his *Miscellaneous Observations on the Tragedy of Macbeth*, as a sample of the critical apparatus he intended to produce. The plan was brought to a halt when a rival publisher, Jacob Tonson, threatened a lawsuit to block this new edition, asserting copyright over Shakespeare's works. Despite the questionable legal authority for such a claim, Cave abandoned the project. By 1756, Johnson was still struggling financially, but enjoyed a far more prominent reputation as the author of the *Rambler* and the *Dictionary*. He was able to contract with a consortium of publishers, wisely including Tonson this time, to produce his edition of Shakespeare. Having failed to learn his lesson from the ordeal of producing the *Dictionary*, Johnson undertook to complete the eight volumes in less than two years. Instead, the work dragged on until 1765, by which time those subscribers who had advanced the money for the work were beginning to share the complaint voiced by Charles Churchill in his poem *The Ghost*:

> "He for *Subscribers* baits his hook,
> And takes their cash—But where's the Book?"

The finished product, however, would be worth the wait. Its Preface became the most important critical statement on Shakespeare in its century. The copy shown here belonged to David Garrick, who by 1765 had become the dominant figure on the London stage and the era's foremost dramatic interpreter of Shakespeare.

90. Samuel Johnson. *Proof Sheet from Taxation No Tyranny*. 1775. MS Hyde 50 (59)

91. James Boswell. *Note on Provenance*. 1778. Manuscript. MS Hyde 50 (59)

In late 1774, the first American Continental Congress passed a series of Resolves which declared unconstitutional the so-called Intolerable Acts, a punitive response

Samuel Johnson. Rowe. 1781. Manuscript. MS Hyde 50 (56) (item 93.)

to the Boston Tea Party, and instituted a boycott of British goods. Seeking to make a forceful response, Lord North's government turned to Johnson, who replied to the colonists' slogan "No taxation without representation" with the pamphlet *Taxation No Tyranny*. As a fierce opponent of slavery, Johnson lashed out at the hypocrisy of the colonists, asking "How is it we hear the loudest yelps for liberty among the drivers of negroes?" North's ministers let that stand, but much to Johnson's dissatisfaction instructed him to strike several passages they considered excessive. One is shown here, in which he suggests that if the colonists need a new king, they should choose William Pitt, leader of the Parliamentary opposition. John Wesley, founder of Methodism, apparently thought Johnson's arguments so persuasive that he plagiarized much of *Taxation No Tyranny* in his own pamphlet, *A Calm Address to Our American Colonies*, published the same year. In 1778, Boswell chanced to find this scrap of the original proof while staying with Johnson at the Thrales' home at Streatham Park, and recorded the moment on the blank verso of p. 82.

92. Samuel Johnson. *POLITICAL TRACTS*. London: W. Strahan and T. Cadell, 1776. *2003J-SJ536

Johnson is known to have inscribed several books as gifts to Boswell, but this is the only such copy of one of Johnson's own works. It collects four pamphlets Johnson wrote in the early 1770s: *The False Alarm, Thoughts on the Late Transactions Respecting Falkland's Islands, The Patriot,* and *Taxation No Tyranny*.

93. Samuel Johnson. ROWE. 1781. Manuscript. MS Hyde 50 (56)

94. Samuel Johnson. PROOFS FOR THE LIFE OF POPE FROM *PREFACES, BIOGRAPHICAL AND CRITICAL, TO THE WORKS OF THE ENGLISH POETS*. 1781. MS Hyde 50 (4)

The crowning achievement of Johnson's career was the publication of *Prefaces, Biographical and Critical, to the Works of the English Poets* (1779–1781). This work would become known as the *Lives of the Poets*, and it first appeared in two forms: collected together in ten volumes and published separately; and appended to a fifty-eight-volume set of the poets' works. In the *Prefaces*, Johnson surveys the lives and work of fifty-two poets. Though he praises the greatest among them, he always employs his judicial and evaluative voice. He also dismisses the inconsequential among the authors, whom the publishers, rather than Johnson, largely chose for

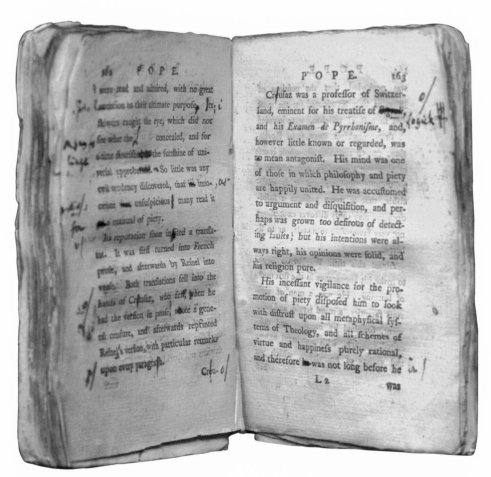

Samuel Johnson. Proofs for the life of Pope from *Prefaces, Biographical and Critical, to the Works of the English Poets.* 1781. MS Hyde 50 (4) (item 94.)

inclusion. The Hyde Collection preserves two important pre-publication items: the manuscript of his essay on Nicholas Rowe (1674–1718) and the proofs of the life of Pope, with Johnson's manuscript corrections. The proofs owe their survival to the novelist Fanny Burney, who asked Johnson to have them saved for her, when they would otherwise have been discarded by the printer after use.

Samuel Johnson. Diary, 1765–1784. Manuscript. MS Hyde 50 (18) (item 95.)

95. Samuel Johnson. Diary, 1765–1784. Manuscript. MS Hyde 50 (18)

Johnson's health, which had vexed him throughout his life, declined in the summer of 1784. He meticulously documented his symptoms and treatments in this journal, written in Latin because, he said, "Dr. Laurence [Thomas Lawrence, his physician] said that medical treatises should always be in Latin." Among his numerous maladies, Johnson was suffering from dropsy (now known as edema), a buildup of fluid in the body, and he took frequent doses of a syrup made from squills, an onion-like plant, as a diuretic. A typical entry, from 26 July, records a sleepless night, doses of squills and diacodium, a syrup derived from opium poppies, and "tristitia gravissima," or terrible sadness.

96. Receipt for pension. December 13, 1784. Printed form with manuscript additions. MS Hyde 50 (50)

In 1762, Johnson was awarded a royal pension of £300 a year by the Prime Minister, the Earl of Bute. It was an uncomfortable position for a man who had defined *pension* as "pay given to a state hireling for treason to his country" and Johnson rightly surmised that he would be charged with hypocrisy for accepting it. Upon assurances that it was offered without the expectation of political services, Johnson accepted the pension, and it provided him with real financial security for the first time in his life. Johnson signed his name to this receipt as one of his last acts. He died just after seven that evening.

97. Invitation to Johnson's Funeral. December 18, 1784. Manuscript. MS Hyde 10 (708)

Johnson was buried a week following his death in Poets' Corner at Westminster Abbey, the final resting place for many of England's greatest writers. The service was performed by his boyhood friend, the Rev. John Taylor.

> The Executors of the late Dr. Samuel Johnson request the favor of your attendance on Monday next . . . at his late dwelling house in Bolt Court Fleet Street to accompany the corpse from thence to Westminster Abbey.

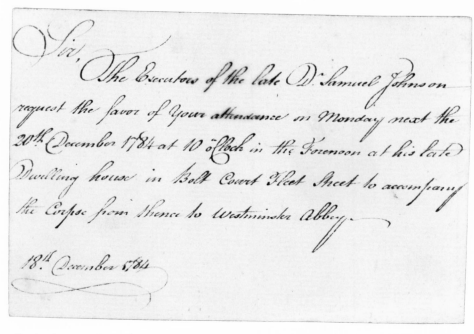

Invitation to Johnson's Funeral. December 18, 1784. Manuscript. MS Hyde 10 (708)
(item 97.)

98. Samuel Johnson. TRANSLATION OF HORACE, BOOK IV, ODE 7. 1784.
Manuscript. MS Hyde 50 (41)

As Johnson did when a student in his teens, he turned to the translation of Horace's
Odes in the last months of his life. The ode, with its theme of mortality, must have
seemed especially relevant to Johnson as he neared the end of his final visit to his
Lichfield birthplace in November 1784. By then he probably knew the answer to
the question posed in the final couplet:

> Who knows if Jove, who counts our score
> Will toss us in a morning more?

The snow dissolv'd no more is seen,
The Fields, and woods, ~~again~~ beholds, are green,
The changing year renews the plain
The rivers know their banks again
The Sprightly Nymph and naked Grace
The ~~night~~ mazy dance together trace.
The changing year's Succession plan
Proclaims mortality to Man.
Rough Winter's blasts to Spring give way,
Spring yield to Summer Sovereign ray,
Then Summer Sinks in Autumn's reign
And Winter chills the World again
Her losses soon the Moon Supplies
But wretched Man, when once he lies
Where Priam and his Sons are laid
Is nought but Ashes and a Shade
Who knows if Jove who counts our Score
Will toss us in a morning more.

Samuel Johnson. Translation of Horace, Book IV, Ode 7. 1784. Manuscript.
MS Hyde 50 (41) (item 98.)

Case 9: NEW ACQUISITIONS

The advertisement of a sale is a signal which at once puts a thousand hearts in motion. . . . He that had resolved to buy no more, feels his constancy subdued; there is now something in the catalogue which completes his cabinet, and which he was never before able to find.

The Idler, No. 56

99. Samuel Johnson. LETTER TO LUCY PORTER. January 13, 1761. Manuscript. *2007M-3

Of Elizabeth Porter's three children, her daughter Lucy (1715–1786) was the most accepting of, or perhaps the least resistant to, her marriage to Johnson. Just six years younger than her new stepfather, Lucy maintained a civil relationship with Johnson that grew increasingly warm as the years passed, becoming one of his most frequent correspondents. She remained in Lichfield after her mother moved to London, living with Johnson's mother Sarah, and helping her to run the bookshop. In 2007, a collection of four letters from Johnson to Lucy Porter came on the market for the first time. Lucy had willed the letters to the Rev. John Batteridge Pearson, at one time curate of St. Michael's Church in Lichfield, and they remained with his descendants for some 220 years.

100. *An Account of the Designs of the Associates of the Late Dr. Bray*. London: [s.n.], 1767. *2008-1094

Thomas Bray (1658–1730) was an Anglican clergyman who worked tirelessly throughout his life to publish and distribute Christian literature, through his founding of the Society for Promoting Christian Knowledge. He also founded parish libraries in England and throughout the colonies. This library-building was carried on after his death by the Associates of Dr. Bray, which regularly published reports on their activities such as this one. The membership list shown here memorializes an intriguing meeting between two of the Associates, Johnson and Benjamin Franklin, at a May 1760 meeting of the society, shortly after Franklin had been named its chairman. Although Johnson remained a member of the group, and bequeathed it the royalties from the posthumous publication of his *Prayers and Meditations*, he is not recorded as having attended any other meetings.

101. Samuel Baker. *A CATALOGUE OF THE VALUABLE LIBRARY OF JOHN WILKES*. [London: Baker, 1764]. *2008-1092

Johnson and rabble-rousing MP John Wilkes (1725–1797) were staunch political opponents, but had many friends in common, most notably Boswell, and when Boswell contrived to invite them both to dinner, Johnson found himself unexpectedly charmed by Wilkes. In his weekly newspaper *The North Briton*, Wilkes directed a scathing stream of criticism toward the governments of Lord Bute and George Grenville in 1762–63. After the publication of the particularly withering issue 45 on 23 April 1763, in which he painted the King as a dupe and puppet of his ministers, Wilkes was arrested for seditious libel, and fled to France to escape prosecution. He was tried and convicted in absentia, and expelled from Parliament. Debts forced him to auction off his home and library, the latter documented by this rare sale catalogue. Wilkes would eventually return both to England and to Parliament, and amass a new library of some 3,000 volumes.

102. W. D. Fellowes. *PARIS, DURING THE INTERESTING MONTH OF JULY, 1815*. London: Gale and Fenner, 1815. *EC75.P6598.Zz815f

This account of the month of Napoleon's abdication and the restoration of Louis XVIII, as reported by an Englishman living in Paris, bears a presentation inscription from the author to his friend Hester Piozzi, and contains several of her annotations. The striking binding on this copy dates from almost a century later. It was done by the famous London bookbinders Riviere & Son in a style known as a Cosway binding, named after the English miniaturist Richard Cosway, for the painted ivory miniature (a rendering of the book's frontispiece) inset in the front cover.

103. William Beville. *OBSERVATIONS ON DR. JOHNSON'S LIFE OF HAMMOND*. London: W. Brown, 1782. *2008-1095

In his *Lives of the Poets*, Johnson dismisses the poetry of James Hammond (1710–1742), concluding that "these elegies have neither passion, nature, nor manners. . . . He produces nothing but frigid pedantry. It would be hard to find in all his productions three stanzas that deserve to be remembered." One wonders if Hammond's close relationship with the Earl of Chesterfield had any impact on Johnson's critical opinions. The author of these anonymously published

observations, William Beville (1755–1822), was known to Boswell, who writes of some negative responses to the *Lives*:

> From this disreputable class, I except an ingenious, though not satisfactory defence of Hammond, which I did not see till lately, by the favour of its author, my amiable friend, the Reverend Mr. Bevill, who published it without his name. It is a juvenile performance, but elegantly written, with classical enthusiasm of sentiment, and yet with a becoming modesty, and great respect for Dr. Johnson.

104. *A Dialogue Between Dr. Johnson and Dr. Goldsmith, in the Shades, Relative to the Former's Strictures on the English Poets, Particularly Pope, Milton, and Gray.* London: Debrett, 1785. *2008-1096

105. George Butt. *A Dialogue Between the Earl of C----------d and Mr. Garrick, in the Elysian Shades.* London: T. Cadell, 1785. *2008-1097

These two rare pamphlets belong to a common eighteenth-century genre, dialogues of the dead, which has its origins in the works of the Greek writer Lucian. These dialogues take the form of a conversation between great deceased personages, who are thus unable to complain about how they are portrayed, and frequently comment satirically on the affairs of the living. Johnson regarded the form as obsolete and overused, and probably would have been appalled to find himself the subject of such a dialogue. He was not alone in that opinion; a 1785 review of the first work in *Town and Country Magazine* begins:

> Dialogues in the Shades have become so hackneyed, that we wonder how the poor ghosts find spirits to keep up the conferences. In the present all Johnson's fire has evaporated, and nothing remains but the mere *caput mortuum* [worthless residue]—save quotations from his own works.

106. William Tytler. *An Inquiry, Historical and Critical, into the Evidence against Mary Queen of Scots*. Third edition. Edinburgh: W. Drummond, 1772. *2008-1091

When this defense of Mary Queen of Scots was originally published in 1760, Johnson reviewed it favorably in the *Gentleman's Magazine*. No doubt his review was at least in part due to the fact that he, too, was sympathetic to Mary. This copy of a later edition is inscribed by the author to Johnson.

107. Samuel Johnson. *The Prince of Abyssinia*. London: R. and J. Dodsley, 1759. *EC75.P6598.Zz759j

108. *The Holy Bible*. Bath: R. Crutwell, 1785. *EC75.P6598.Zz785b

The Hyde Collection contains more than a hundred volumes from the library of Hester Thrale Piozzi, but two of the most important items have only recently been added. Although unannotated, her copy of *Rasselas* certainly has great iconic significance, and she has inscribed this copy twice: first to Gabriel Piozzi, and later to her adopted son, Sir John Salusbury Piozzi (1793–1858). The Bible, by contrast, is extensively annotated, making clear that it was the subject of prolonged study on Mrs. Piozzi's part, and adding greatly to our understanding of her.

109. J. & W. Newton. *Plan of Streatham Park*. 1822. Watercolor on vellum. *2007M-5

After Hester Thrale Piozzi's death in 1821, this survey of her home, Streatham Park, was commissioned by her daughters Hester, Susanna, and Cecilia. It was then incorporated into the 1825 deed of sale of the property to Michael Shepley. The property passed through the hands of a series of owners, eventually falling into ruins, and was demolished in 1863.

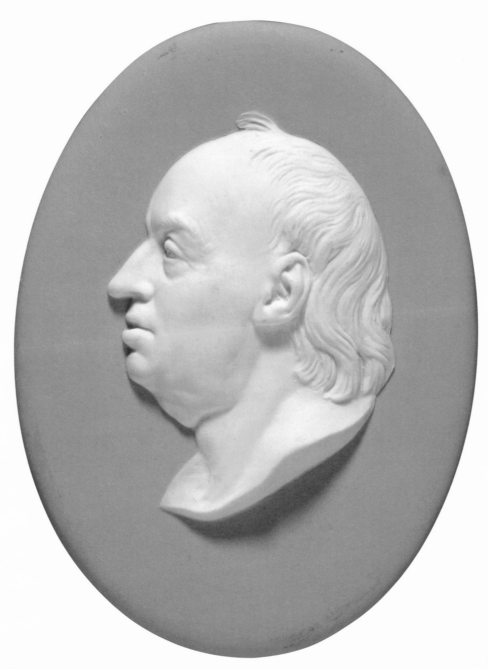

Josiah Wedgwood & Sons. *Samuel Johnson*. 1784. Jasperware. *2003JM-214 (item 111.)

Case 10: Johnson as Icon

Whoever is delighted with his own picture must derive his pleasure from the pleasure of another. Every man is always present to himself, and has, therefore, little need of his own resemblance, nor can desire it, but for the sake of those whom he loves, and by whom he hopes to be remembered.

<div align="right">

The Idler, No. 45

</div>

110. TRADESMEN'S TOKENS DEPICTING SAMUEL JOHNSON. 1793, 1796, and undated. *2003JM-216

Due to a shortage of official small-denomination copper coinage in the 1790s, the practice of manufacturing private tokens briefly flourished in order to facilitate small commercial transactions. These three halfpenny tokens, issued in Lichfield and Birmingham, depict Johnson as a civic hero and counterpart to the royal portraits on official coinage.

111. Josiah Wedgwood & Sons. *SAMUEL JOHNSON*. 1784. Jasperware. *2003JM-214

Josiah Wedgwood (1730–1795) began issuing a series of profile portraits of "Illustrious Moderns" in 1773. The subjects included Johnson's contemporaries Joshua Reynolds and Benjamin Franklin, as well as earlier luminaries such as Louis XIV and Shakespeare. The portrait was the work of John Flaxman (1755–1826), an artist for the Wedgwood firm, and may have been taken from the life.

112. *SHORTLY WILL BE PUBLISHED, (BY SUBSCRIPTION) A PORTRAIT OF SAMUEL JOHNSON, LL.D.* [London: A. Wivell, 1815]. *2003J-SJ1198

113. William Thomas Fry, after Abraham Wivell. *SAMUEL JOHNSON, L.L.D. . . . FROM THE ORIGINAL BUST BY JOSEPH NOLLEKENS.* [London: A. Wivell, 1815]. MS Hyde 100

In 1776, Johnson sat for the era's leading sculptor of portrait busts, Joseph Nollekens (1737–1823), who entered the result in an exhibition at the Royal Academy the

following year. Johnson was pleased with the likeness, but his female friends, including Lucy Porter and Hester Thrale, appear to have rejected it. Abraham Wivell, who found his entrée to the world of art in his role as Nollekens' barber, offered an engraving of his drawing of the bust in 1815, advertised by means of the prospectus shown here. Although Nollekens' original clay model of the bust is now lost, a marble version graces Johnson's memorial in Westminster Abbey.

114. *Incidents in the Life of Dr. Johnson*. London: R. S. Cartwright, [ca. 1900]. *2008-1928

This set of picture postcards, issued by a publisher who resided in Johnson's Court (Johnson's home for a decade, although he is not the Johnson for whom it is named), is based in part on the paintings of Edward Matthew Ward (1816–1879) who specialized in scenes from the lives of literary greats. Ward's painting *Doctor Johnson in the Ante-Room of the Lord Chesterfield Waiting for an Audience, 1748* (a copy of which is in the Hyde Collection) depicts a oft-retold anecdote (denied by Johnson) that Chesterfield kept Johnson waiting for an hour while His Lordship chatted with the comic actor Colley Cibber, and that Johnson stormed out upon learning of the slight.

115. A. Edward Newton. *Wit and Wisdom of Dr. Johnson and His Friends*. Philadelphia: Edward Stern & Co., 1908. Calendar. *2003J-SJ1041 (1)

Beginning in 1907, Newton issued a series of "Christmas Greetings" to friends and associates, until his death in 1940. The greetings eventually took the form of a short essay on one of Newton's collecting interests, but the first two were calendars consisting of quotations from an author.

116. Percy Hetherington Fitzgerald. *Samuel Johnson,* 1910, and *James Boswell,* 1908. Painted plaster. *2003JM-24 and *2003JM-25

Johnsonian collector and scholar Percy Fitzgerald (1834–1925) was also an artist, responsible for two prominent statues of Boswell and Johnson, the models for which are displayed here: the statue of Johnson at St. Clement Danes Church in London, and of Boswell in Lichfield Market Square.

Incidents in the Life of Dr. Johnson. London: R. S. Cartwright, [ca. 1900]. *2008-1928
(item 114.)

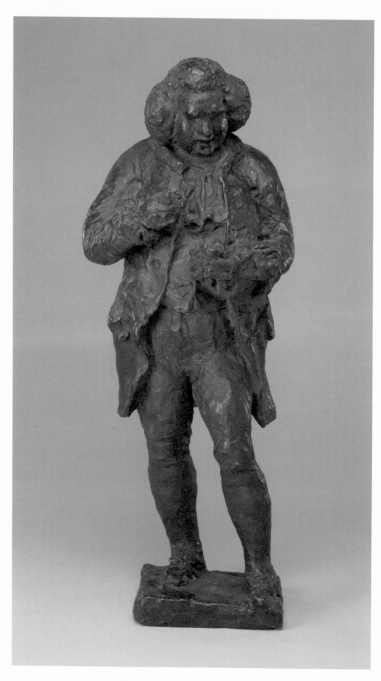

Percy Hetherington Fitzgerald. *Samuel Johnson*. 1910. Painted plaster.
*2003JM-24 (item 116.)

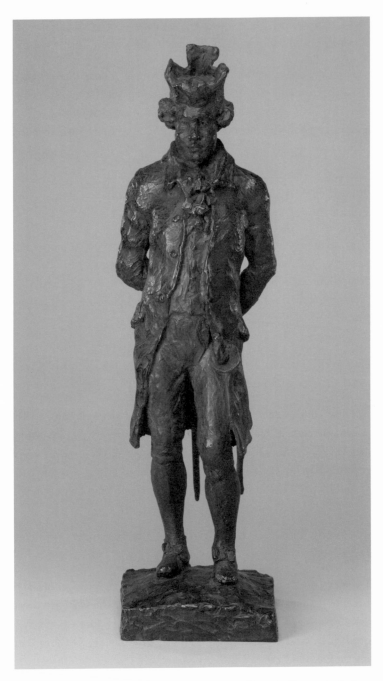

Percy Hetherington Fitzgerald. *James Boswell*. 1908. Painted plaster.
*2003JM-25 (item 116.)

117. Miguel Covarrubias. *Impossible Interview: Dr. Johnson and Alexander Woollcott*. 1935. Gouache on paper. *2003JM-21

A long-running series in *Vanity Fair* paired Miguel Covarrubias' instantly recognizable caricatures of two unlikely companions with John Riddell's imagined dialogue between them. This installment, from the March 1935 issue, brings Johnson together with the critic and Algonquin Round Table wit Alexander Woollcott (1887–1943).

118. Micromodels, Ltd. *Doctor Johnson's House, 17 Gough Square*. Papercraft model. 1949. MS Hyde 100

In the 1940s and 50s, the popular Micromodels line of paper model kits included trains, ships, and buildings ranging from Stonehenge to St. Paul's Cathedral. This particular kit offered a landmark more famous for its literary significance than its architectural merit, the house in Gough Square where Johnson wrote the *Dictionary*.

119. Barclay Perkins & Co. *Beer Bottle Labels Depicting Samuel Johnson*. 1950. MS Hyde 100

After Henry Thrale's death in 1781, Johnson, acting as an executor of Thrale's will, negotiated the sale of his Anchor Brewery to the newly created firm of Barclay Perkins & Co. (Perkins having been the manager of the brewery under Thrale's ownership). Barclay Perkins, which endured until a 1955 merger with Courage, honored its connection to Johnson by placing his portrait on its labels.

120. Peter Ustinov. *Prop Samuel Johnson Letter*. 1957. Manuscript. MS Hyde 10 (715)

Peter Ustinov (1921–2004) won an Emmy for his 1957 portrayal of the title role in "The Life of Samuel Johnson" on the television show *Omnibus*. He wrote this faux Johnson letter on the back of a handy piece of scrap paper—an angry letter from Mrs. Hazel D. Svatos of Chicago, Illinois, denouncing NBC for "ramming an asinine program like the *Bob and Ray Show* down the people's throats."

Selected Sources

Austin, Gabriel, ed. *Four Oaks Library*. Somerville, N.J.: 1967.

Bate, W. Jackson. *Samuel Johnson*. New York: Harcourt Brace Jovanovich, 1977.

Bond, W. H., ed. *Eighteenth-Century Studies in Honor of Donald F. Hyde*. New York: Grolier Club, 1970.

DeMaria, Robert, Jr. *The Life of Samuel Johnson: A Critical Biography*. Oxford: Blackwell, 1993.

Eccles, Mary Hyde. *The Impossible Friendship: Boswell and Mrs. Thrale*. Cambridge, Mass.: Harvard University Press, 1972.

Fleeman, J. D. *A Bibliography of the Works of Samuel Johnson*. Oxford: Clarendon Press, 2000.

_____. *A Preliminary Handlist of Copies of Books Associated with Samuel Johnson*. Oxford: Oxford Bibliographical Society, 1984.

_____. *A Preliminary Handlist of Documents & Manuscripts of Samuel Johnson*. Oxford: Oxford Bibliographical Society, 1967.

Houghton Library. *An Exhibit of Books and Manuscripts from the Johnsonian Collection Formed by Mr. and Mrs. Donald F. Hyde at Four Oaks Farm*. Cambridge, Mass.: Houghton Library, 1966.

Liebert, Herman W. *Lifetime Likenesses of Samuel Johnson*. Los Angeles: Clark Memorial Library, 1974.

Page, Norman. *A Dr. Johnson Chronology*. Boston: G.K. Hall, 1990.

Reddick, Allen. *The Making of Johnson's Dictionary, 1746-1773*. Cambridge: Cambridge University Press, 1990.

Redford, Bruce, ed. *Designing the Life of Johnson: The Lyell Lectures, 2001-2*. Oxford: Oxford University Press, 2002.

_____. *The Letters of Samuel Johnson*. Princeton, N.J.: Princeton University Press, 1992-94.

Rogers, Pat. *The Samuel Johnson Encyclopedia*. Westport, Conn.: Greenwood Press, 1996.

Yung, Kai Kin. *Samuel Johnson, 1709-84: A Bicentennial Exhibition*. London: Arts Council of Great Britain, 1984.

Contributors

James Engell is Gurney Professor of English and professor of comparative literature at Harvard University, where he has served as chair of the Department of English since 2004. Author and editor of numerous books on eighteenth- and nineteenth-century literature and criticism, current issues in higher education, and environmental studies, he has published several articles and book chapters on Johnson, edited *Johnson and His Age*, and is a member of the editorial committee of the Yale Edition of the Works of Johnson. Among his regular course offerings are ones covering all genres of eighteenth-century British literature.

Thomas A. Horrocks is Associate Librarian of Houghton Library for Collections. He received his Ph.D. in history from the University of Pennsylvania, where he focused on early American history, the history of the book in American culture, and the history of medicine in early America. He is the author of *Popular Print and Popular Medicine: Almanacs and Health Advice in Early America* (University of Massachusetts Press, 2008) and *Harvard's Lincoln* (a special issue of the *Harvard Library Bulletin*, Fall-Winter 2008). He is currently writing a biography of James Buchanan.

John Overholt is Assistant Curator of the Donald & Mary Hyde Collection of Dr. Samuel Johnson and Early Modern Books and Manuscripts. He joined Houghton Library in 2004 as the cataloguer of the Hyde Collection printed books.

William Zachs is an Honorary Fellow at the University of Edinburgh. He is the author of *The First John Murray and the Late Eighteenth-Century London Book Trade* and *Without Regard to Good Manners: a Biography of Gilbert Stuart 1743-1786* and the editor of *Mary Hyde Eccles: A Miscellany of Her Essays and Addresses*. He lives in Edinburgh, where he writes and teaches about the book trade and book collecting. He is an avid collector himself.

A Monument More Durable Than Brass:

The Donald & Mary Hyde Collection
of Dr. Samuel Johnson

was designed by Duncan G. Todd and typeset in
Baskerville types from Storm Type Foundry.
Eight hundred copies were printed
on 80 lb. Mohawk Superfine by
Universal Millennium, Inc.
and bound by Acme
Bookbinding.